wear it out

Concrete to Canvas: Skateboarders' Art

Jo Waterhouse and David Penhallow

Watson-Guptill Publications/New York

First published in the United States in 2006 by
Watson-Guptill Publications,
a division of VNU Business Media Inc.,
770 Broadway, New York, NY 10003
www.wgpub.com

Library of Congress Card Number: 2005927696

ISBN: 0-8230-0887-8

 This book was designed and produced by
Laurence King Publishing Ltd, London
www.laurenceking.co.uk

Designed by David Penhallow

Printed in China

1 2 3 4 5 6 / 10 09 08 07 06 05

Cover: Digital artwork by Niko Stumpo
Pages 1 & 128: **Wear it out/Don't wear it out** by Chris Bourke
Contents, Introduction and Foreword titles by Chris Bourke

Contents

foreword

Skateboarding, like art, is about opportunities. It's about creativity. It's about being creative enough to take your opportunities and make the best of them. Create fun. Create havoc. Create something new and original. Skateboarding is about looking at an object and seeing it in a completely different light from 99 per cent of the people on this planet. It's about taking that object and adapting it, applying a brand new technique to it. Skateboarding is about grabbing those opportunities, about skating that bank that's usually a bust except for the 15 minutes between 5:30 pm and 5:45 pm when the guards change shifts. It's about seeing opportunities where none had existed before. Skateboarding can be about pain but it's invariably about joy – all kinds of successes and achieving goals.

But you get out of it what you put into it. You'll find your skills improve with practice; your techniques improve over time. Your judgement even improves along with all of that eventually. Skateboarding is about frustration: the inability to land that trick; the inability of your parents or teachers to understand your obsession with a 'useless piece of wood'. Skateboarding mirrors real life like a charm: success, setbacks, downfalls, disappointments, victories, defeats, slams, lands, learning and forgetting. Around the next corner could be a cop or a brand new slick ledge you've never seen before. You may get harassed or assaulted. But there's only one way to find out. Don't be afraid. Give it a good push and see what happens next. If you're scared, push just a little harder. Oh yeah, I'm not talking about skateboarding any more. I'm talking about life. But for a skateboarder it's the same thing.

The other day my partner at Hessenmob, Michael, asked me if I remembered Billy Ruff. I said, 'No, I don't remember Billy but I do remember his graphic. He had a lot of bubbles on his pro board.' Being a thirty-something with a life full of skating behind me, I do remember a lot of pros only because of their pro-board graphics. Outstanding graphics, like the 'Gator', 'Rob Roskopp' or pretty much any old Santa Cruz, Powell or Vision graphic for that matter, come to mind.

Skateboard graphics have always offered a wide variety of styles from the highly skilled artwork of Jim Phillips to the rather amateurish scribbles of Mark Gonzales, but what all skateboard graphics had and have in common is that they are uncensored expressions of the artist (depending on the company) and they are made to be destroyed. The colourful pictures on the bottom of a skateboard are therefore one of the purest forms of artistic expression: highly personal and mostly created without artistic boundaries – just like skateboarding itself. I think this is a reason why so many skateboarders are artistically gifted in the many fields of personal expression. This may be art, photography, music, film-making or graphic design.

The skateboard is like a brush. The streets are the canvas and every skateboarder is an artist. It does not matter if your brush stroke is flowing or if your style is technical – everything you do on a skateboard has the potential to be a direct expression of your personality. Skateboarding keeps your mind open and the creative juices flowing because of its endless combinations. The deciding factor is always your own creativity.

Christian Roth – Hessenmob Skateboards
http://www.hessenmob.de.

introduction

The idea for this book came about while we were working on our website, coldspace.net, writing about artists who are skateboarders and reviewing books about art and design. It occurred to us that there wasn't a book that solely featured the work of skateboarders who are artists, and wouldn't it be great if such a book existed. In keeping with the true DIY spirit of skateboarding we decided to produce the book ourselves.

So the main idea for this book was to create something that we, as people interested in and passionate about skateboarding and art, would want to buy. We wanted simply to bring together the work of skateboarders who are artists, and artists who are skateboarders, and to represent the fresh, exciting art that's being produced by this group of people, from what is essentially a subculture within a subculture.

We wanted the artwork to speak for itself without it getting lost in graphic references to skate culture. Therefore the design of this book is deliberately clean and minimal to allow the focus to remain entirely on the artists' work.

The diversity and quality of the work in Concrete to Canvas demonstrate how art produced by skateboarders cannot easily be pigeonholed or given a handy 'one size fits all' label. It is varied, unique, multi-discipline and crosses many genres, with fine art rubbing shoulders with doodles, illustration, graphic design and street art.

The artwork within the book doesn't necessarily directly relate to skateboarding in any way, as the focus of the book is on personal artwork by skateboarders, whatever form that may take. This may include skateboard graphics, or associated styles, but sometimes the work has a more esoteric connection to skateboarding.

Some of the artists featured were initially inspired by the graffiti they saw while out skateboarding. The collision of these two aspects of street culture was the starting point for their interest in art, leading them into creating their own graffiti and often into experimenting with other art forms.

Dave the Chimp is a respected street artist from London, who, in addition to his street work, has also produced board graphics for UK-based Feeble Skateboards and Germany's Hessenmob Skateboards. He explains the direct correlation between his art and skateboarding:

> Since being a kid, everywhere I go I'm looking for spots to skate, looking for those little opportunities hidden in the architecture, and since starting to paint graffiti six years ago I'm on double alert, constantly searching not only for things to skate, but also things to paint on (and lately, how to get onto rooftops to paint!). One of the ways my street art is different from most people's is that it's mostly site-specific, and often uses elements of the architecture that are already there, just like skateboarders do.

For other artists, the link between skateboarding and their art is more about the creative force that drives them both, as UK artist Log Roper explains:

> I've never really differentiated between all the creative things I do, be it skating, photography, music, drawing, design or painting. To me it feels like the same process: observation, imagination, application. Art's like skating: you don't even think about it, you just get that creative urge and do it.

Skateboarding's art history began the first time an image was hand-drawn onto a skateboard back in the 1970s, creating an instant and disposable canvas that, as board graphics developed commercially, would inspire generations of skateboarders over the years. Many of the artists featured in the book were initially motivated by this visual art

culture of skateboarding. The multitude of board graphics featuring a diverse range of images, from the childlike doodles of Mark Gonzales to the dark, detailed skulls of Pushead, caught the eye of many of these artists, and was the trigger for their own forays into art.

Brooklyn-based artist James Marshall a.k.a. Dalek was one of many who were inspired to take up drawing after being immersed in skateboard culture from a young age. As he explains:

Skateboarding has played a profound role in my life and in my creative drive. My first artistic inspiration was Pushead. That's why I rode Zorlacs as he did all the graphics. It made me want to draw all the time, and I did. Throughout the years it kept on rolling, seeing Neil Blender graphics, Chris Miller, Andy Howell, Mark Gonzales and Ed Templeton. Skateboarding rocks.

Simon Peplow could well have become a professional skater had he not chosen to concentrate on art and illustration. His artistic awakening came about through his interest in skateboarding and skateboard graphics.

The first board that really got me psyched to create my own images was a Blind Mark Gonzales mini. The graphic was a bunch of childlike doodles and squigglings. I think it was around this time that I showed a genuine interest and passion for the endless possibilities in graphics and the arts. Skateboarding in general forces you to view and tackle things in life and art in an exciting and original way. For that I am forever grateful.

For Max Estes, an artist and illustrator from Milwaukee, the visual culture of skateboarding has a huge impact on his work as an artist.

Skateboard decks were the new canvases: versatile and fresh. The graphics I saw on skateboards blew my mind; they were the comic books of my day. It is impossible for me to separate the influence of skateboarding from my visual art, even today. Although my visual work is often outside of the perceived boundaries of skateboarding, I still find parallels that bring me back.

It could be said that art and skateboarding are two sides of the same creative coin; that art and skateboarding share the same creative impulse and outlet felt by those that participate. Skateboarding allows for creative interaction and re-interpretation of your environment, as do other art forms. It encourages a creative way of thinking, and for many that creativity is effortlessly transposed from the concrete to the canvas, or vice versa.

'I guess there are a lot more skaters than say footballers, that paint, write, film or whatever,' says Worcester-based artist Chris Bourke. 'I just think that skating attracts something in those folk. It's like a little club of misfits. I feel right at home. I think that skating itself is inherently creative: that's how it progresses, people push it forward.'

The emergence over the years of this global community of skateboarding artists has been wholly organic. It grew from groups of people quietly working away at their art and supporting each other through genuine enthusiasm and interest in the work that was being produced. They had existed until fairly recently without the knowledge or support of the wider 'art establishment', retaining the DIY mentality so integral to skateboarding. Shows and exhibitions were being put on by the skateboarders and artists themselves, with deliberately little or no regard for what else was going on in terms of the rest of the mainstream art world, in keeping with the anti-establishment spirit of skateboarding.

The purpose of this introduction isn't to over-intellectualize about the connection between skateboarding and art, or to document fully the history of the visual culture of skateboarding, as that would be a book in itself, and skateboarding isn't about intellectualizing; it's about getting on and doing it. Skateboarders' art can also exist as an entity in its own right, outside skate culture, and can be viewed in isolation without necessarily needing to know its roots or history.

This book is only intended as a snapshot of the work being produced by skateboarders and artists who skateboard. There are many more artists out there, some we really wanted to feature here but were unable to, because of space limitations or time restrictions. A massive thank you goes out to all the artists who have contributed to the book and made it possible through their help and generosity.

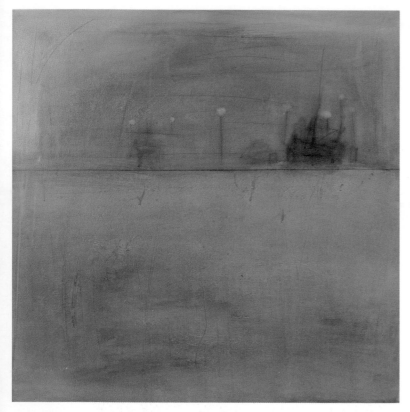 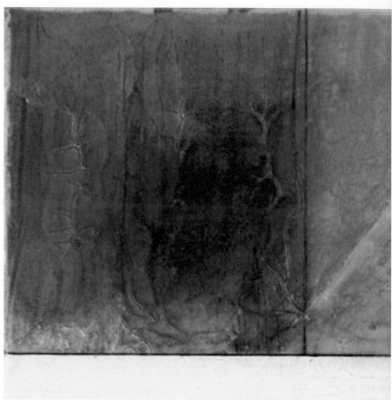

Rob Abeyta Jr

Rob Abeyta Jr, originally from Chicago, is a fine artist, graphic designer, film-maker and photographer who lives in California. There he works as art director for Four Star Clothing, which comes under the Girl Skateboards umbrella. This also makes him a member of the notorious and affectionately named Girl Art Dump, alongside Andy Jenkins and Andy Mueller. Rob has exhibited throughout the US, and in Tokyo and Australia as part of group shows. He uses a combination of oil, gouache and graphite on canvas to produce his work. His latest film and design project is Ink, a film and book documenting the art of tattooing in Los Angeles. Ink is being produced in collaboration with

Mr Cartoon and Estevan Oriol, with whom Rob has worked previously on several design projects, including CD packaging for Cypress Hill and Everlast. Rob has also produced packaging for the 'Director's Label' DVD series, featuring the work of Spike Jonze and Michel Gondry.

http://www.suprememundane.com
http://www.girlskateboards.com

Above left: **Bar taruga piazza**
Above right: **Vincent thomas bridge**

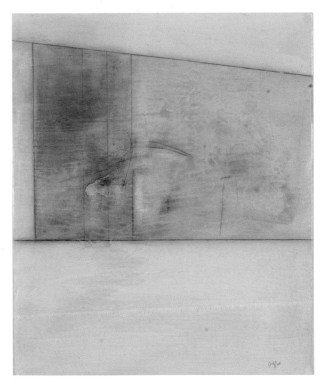 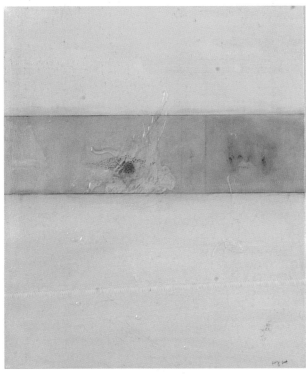

Rob Abeyta Jr

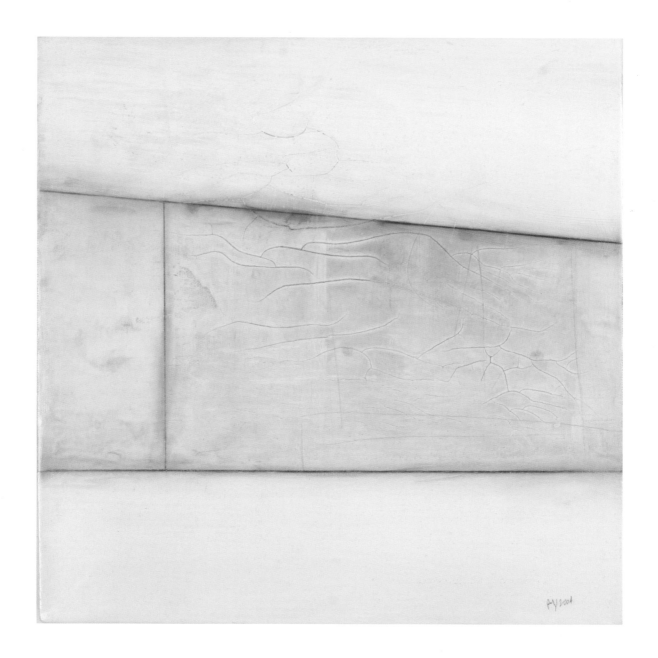

Rob Abeyta Jr

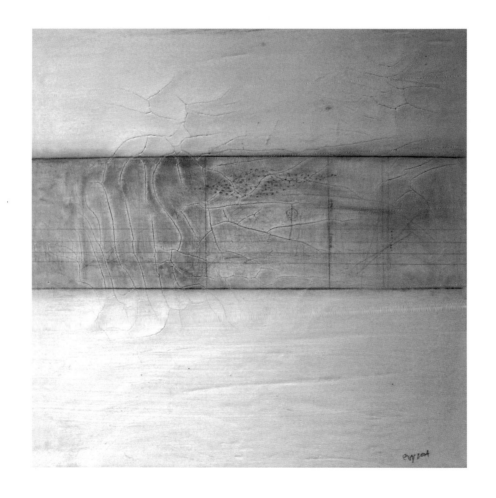

Left & above: **Skid row series**

Rob Abeyta Jr

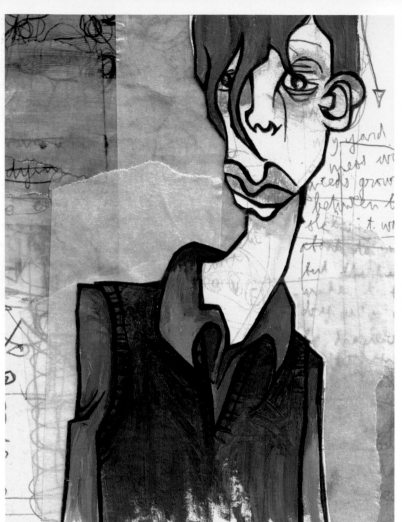
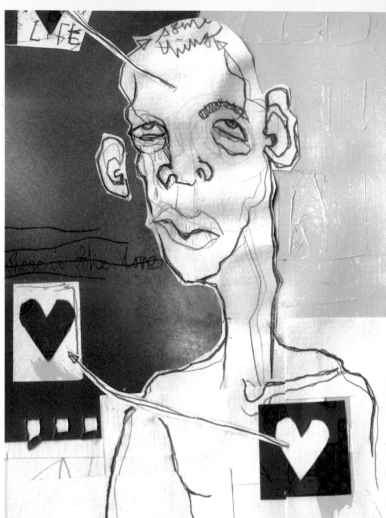

Vaughan Baker

Professional skateboarder Vaughan Baker is based in London and has been drawing since childhood: 'For as long as I remember I drew pictures when I was younger, mainly of my toys and characters out of my favourite comics and cartoons, but when I started skateboarding that changed to skate logos and people riding skateboards.' He began skating in 1991 after being 'blown away'. by seeing skaters in an indoor car park in Worcester. 'Nowadays I tend to draw whatever comes out. Just putting pen to paper and seeing what happens, not really thinking, just letting my emotions do the work.' He uses a variety of materials and techniques to produce his artwork including pen, pencil, acrylic, spray paint and collage, and his favourite artists include Warhol, Dalí, Picasso and Schiele. He has exhibited in group and solo shows in London and is a member of the Outcrowd Collective.

http://www.outcrowdcollective.com

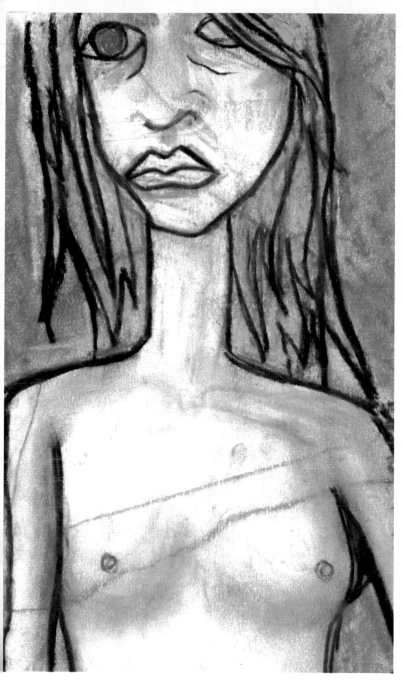
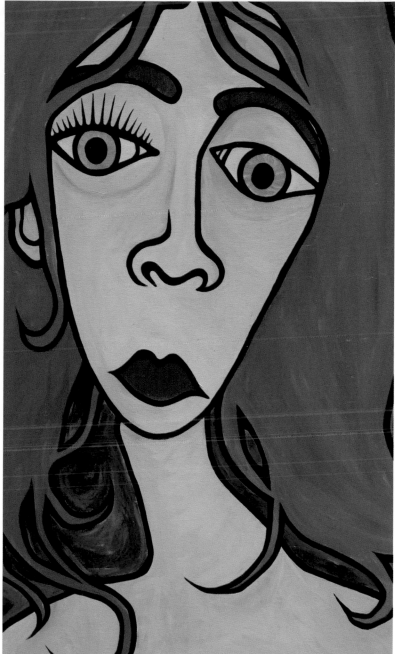

15

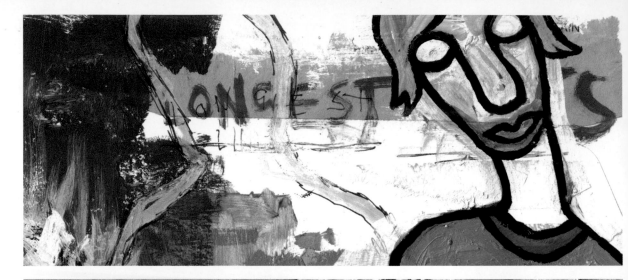

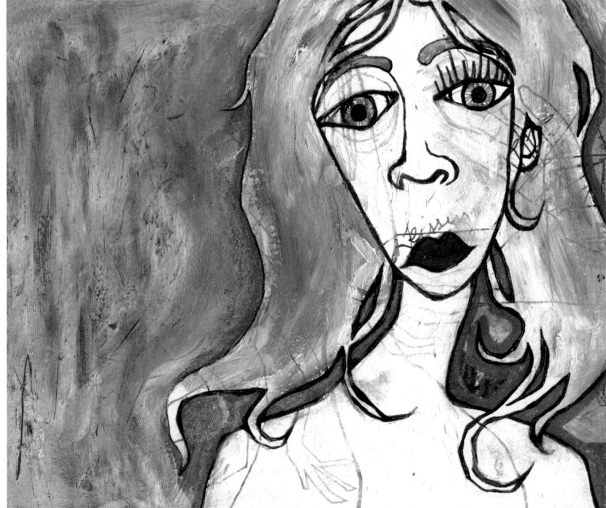

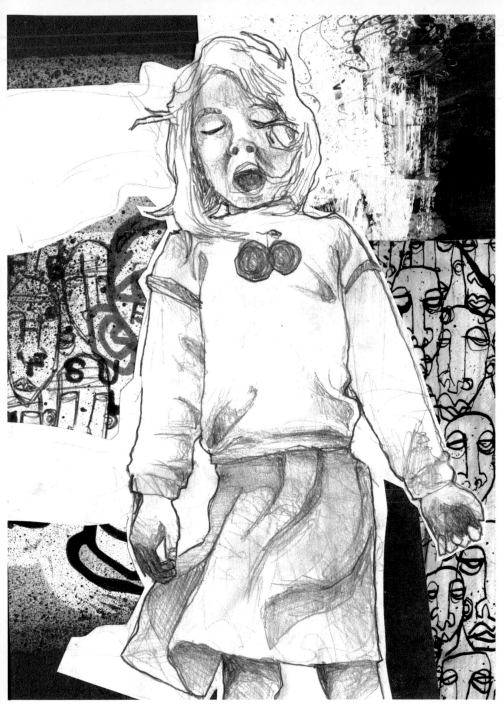
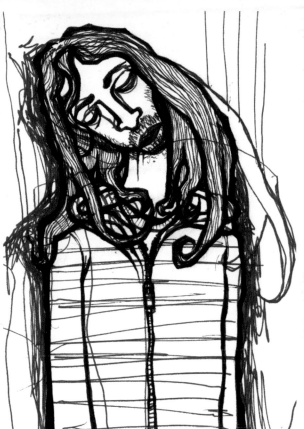

Vaughan Baker

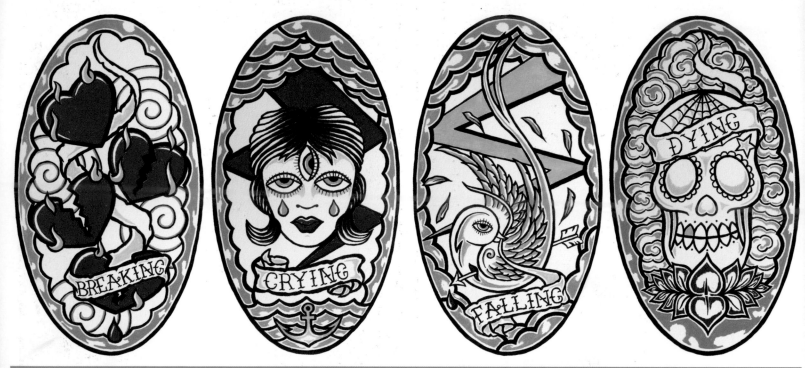

Chris Bourke

Chris Bourke is an artist and skate-shop owner based in Worcester, UK. 'I went to school in Handsworth, Birmingham where my art teacher ripped up one of my pictures in front of the whole class, but despite this early criticism I managed to go on to attend art college for four years.' Chris got hooked on skating in 1986 whilst living in Droitwich, and opened his own skate shop, Spine, in Worcester in 1999. He was previously a tattoo artist, and the influence of tattoos is present in his personal and commercial work, which includes a recent series of board graphics for Birmingham-based skateboard company A Third Foot. 'The tattoo-inspired "Falling, Breaking, Crying and Dying" is the darker side to last year's "Feeding, Growing, Shining and Flying" series,' he explains. In

the past Chris has used spray paints and acrylics to create his work, but more recently he has turned to watercolours to produce large, distinctive paintings infused with his interests and influences, which include tattoo art, religious symbolism and his travels to India and Nepal. Chris is a member of the Outcrowd Collective and has exhibited at the Custard Factory in Birmingham alongside friends and Outcrowd founders Log Roper, Simon Peplow and Vaughan Baker.

http://www.spineskateboarding.co.uk
http://www.outcrowdcollective.com

Above from left:
Breaking, Crying, Falling, Dying

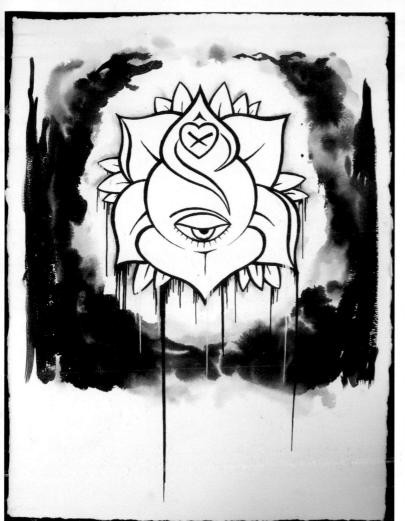

Above left: **Rose 2**
Above right: **There is a light that never goes out**
Left: **Nothing and everything**

Chris Bourke

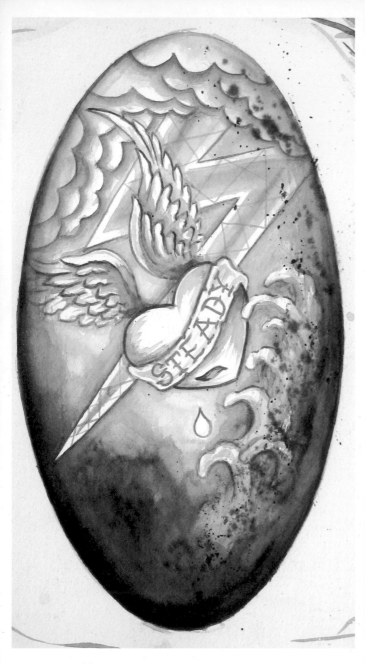

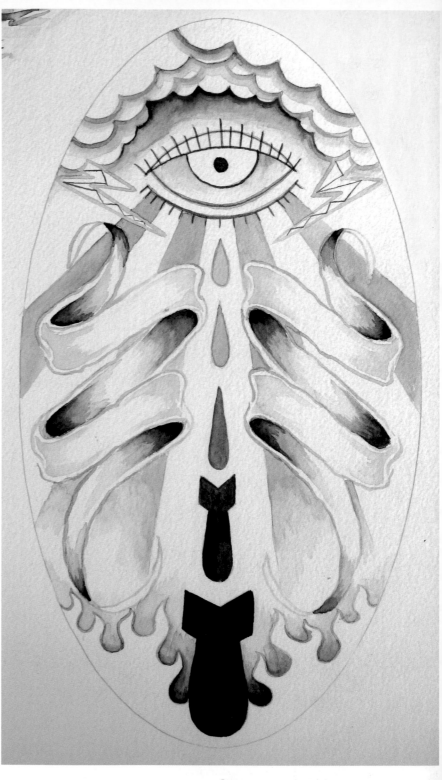

Above: **Steady**
Right: **Bombs**

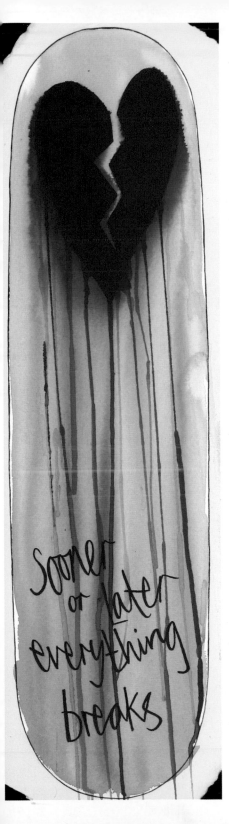

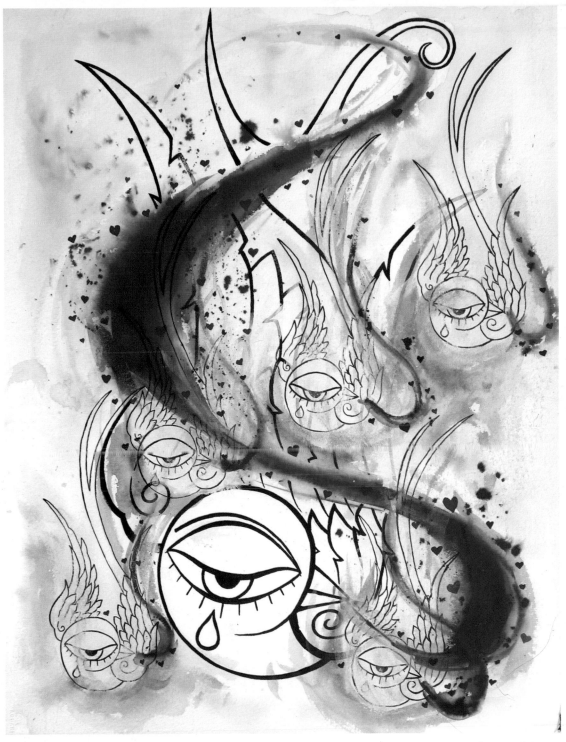

Left: **Sooner or later**
Above: **Six of billions**

Chris Bourke

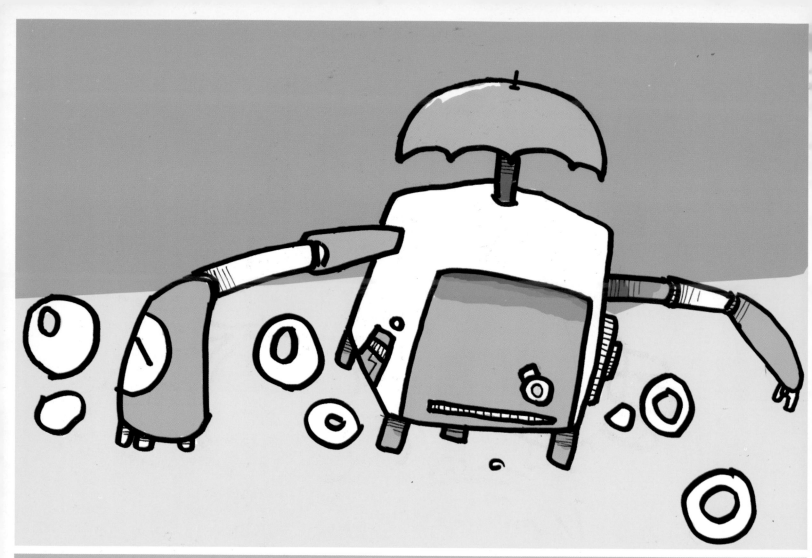

Eric Broers

'Seven-ply horses have been a part of my life since I was knee-high to a grasshopper,' says Eric. 'Growing up, my next-door neighbour had a yellow plastic banana board, and even though I couldn't quite stand on it yet I would crawl around for hours and hours with the deck under me, like an alligator.' Eric Broers is a graphic designer, illustrator and model-maker from Chicago. His commercial work includes CD packaging, web design, advertising and T-shirt and sticker designs, as well as a collectable, acrylic-painted robot sculpture called a See Vea. Eric loves robots and his unique robot creations feature heavily in his work. His parents bought his first skateboard when he was six years old from a local toy store, as there were no skate shops in the area:

Unfortunately, it didn't have any grip tape. I decided to give it a new paint job, and put sand in the mixture before it dried. Without realizing it, I was putting art and skateboarding physically together. This became a way of life for me. The two have given me the opportunity to constantly experiment and evolve, and have allowed for personal expression and improvisation using the tools at hand.

http://www.phoneticontrol.com

Above: **Levitating umbrella refrigerator with doughnuts**
Right: **Thought shower**

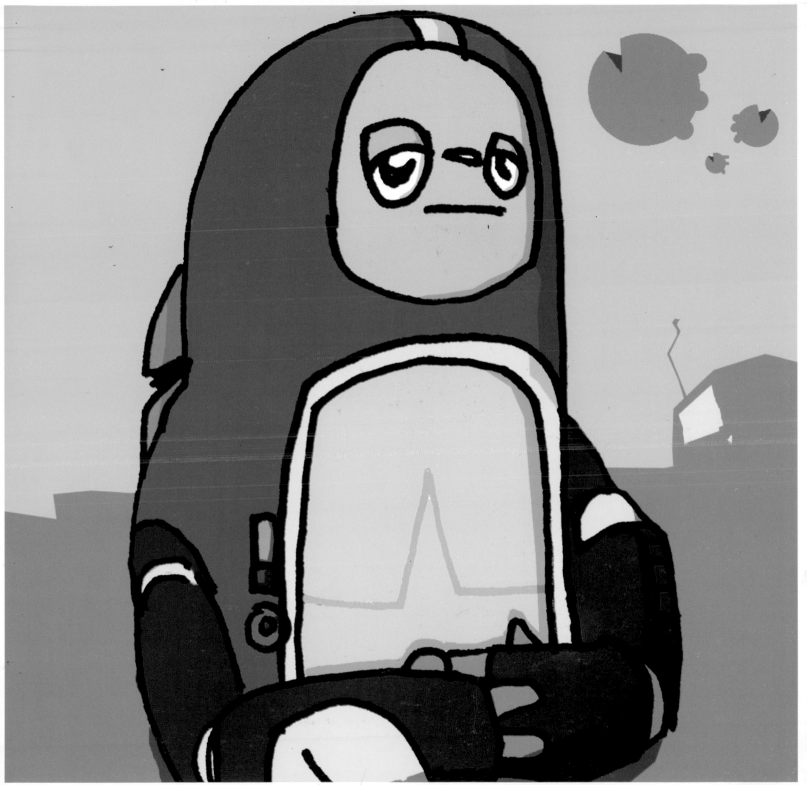

Eric Broers

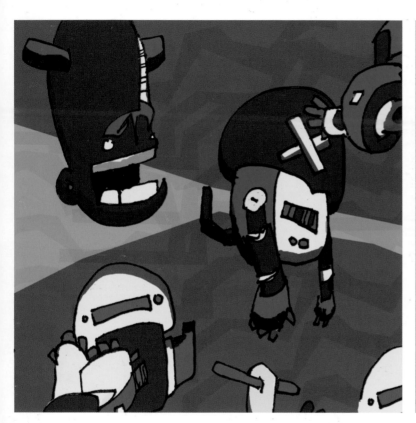
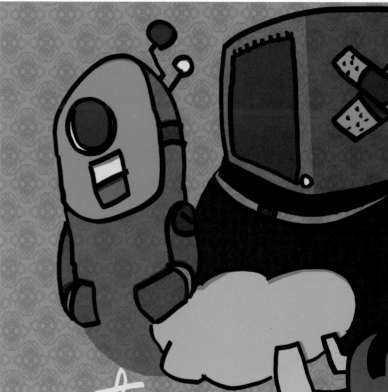

Above left: **Cross head floats home after a long day at the office, accompanied by peanut gallery**
Above right: **My television head is broken, will you fix it, cloud?**
Opposite page: **Utilisation of floatation devices in assemblage**

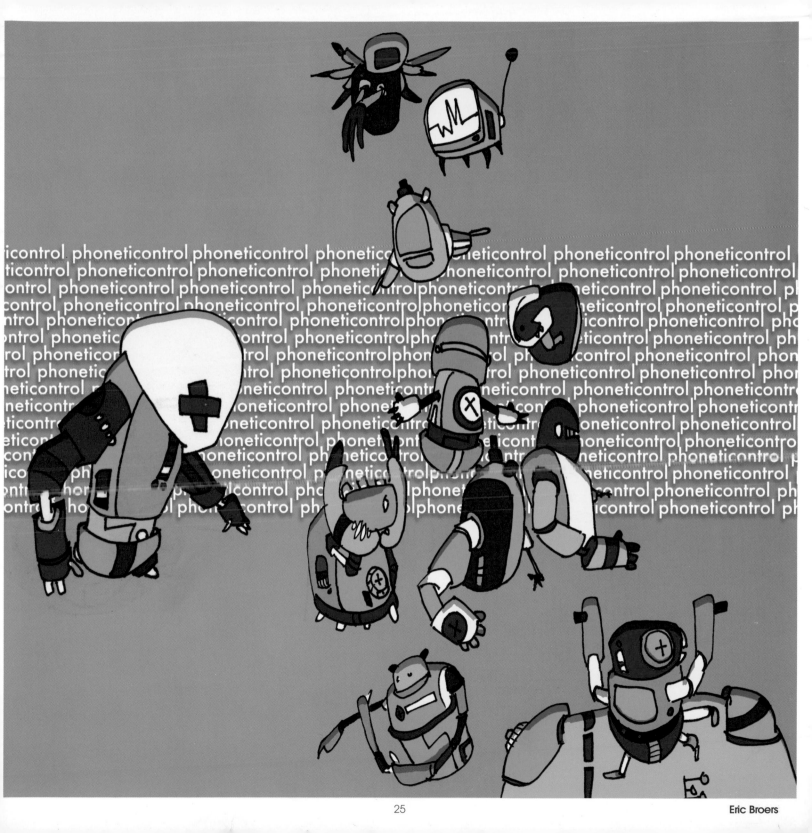

Eric Broers

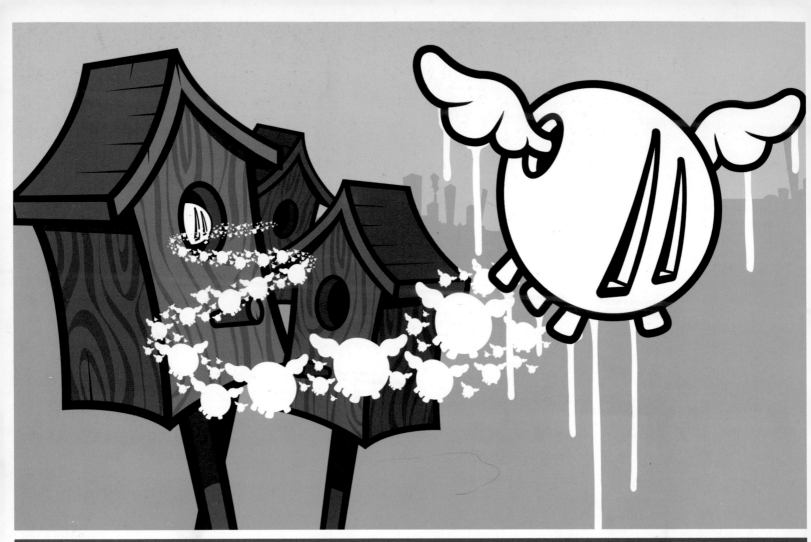

D*Face

D*Face is a prolific street artist from London. His trademark monochrome 'Balloon Dogs' and 'D*Face' characters can be seen dotted around the streets of London, Munich, Berlin, Barcelona and Amsterdam. He has recently been working on '*Face Value', a project involving customizing banknotes and putting them into circulation.

Originally inspired in his formative years by the graffiti he saw when out skateboarding, D*Face keeps the anti-establishment spirit of skateboarding alive in his work and challenges us to look differently at what's around us.

I think it would be fair to say that skateboarding has pretty much directed my life, even dictated my life. From that first board on, I lived to skate. I was fascinated not just with the act of skateboarding, but also the graphics associated with the brands, and what kind of person got the dope job of doing the artwork. I just thought I want to do that.

http://www.dface.co.uk

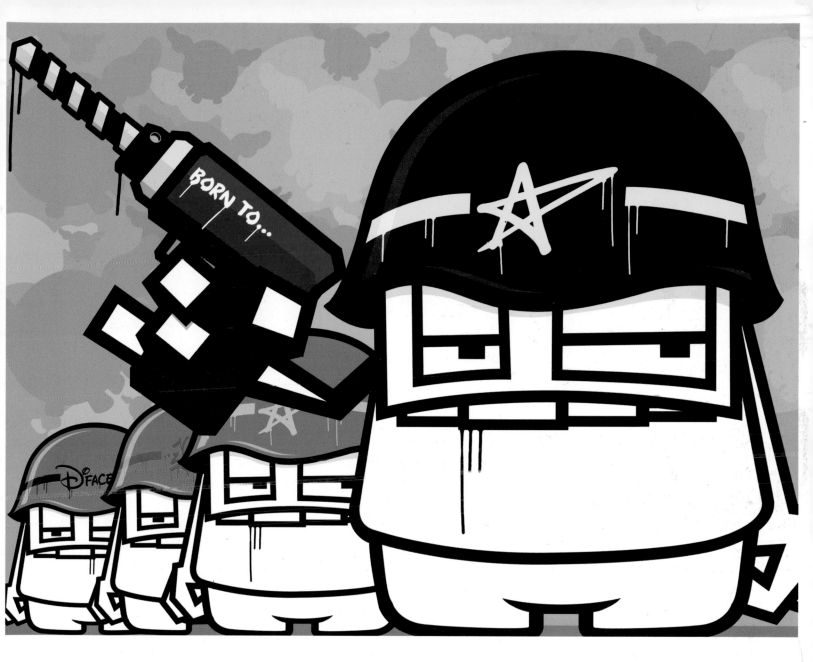

Opposite page: **Bird box**
Above: **Born to drill**

D*Face

Left: **Hand of god**
Right: **Law school**

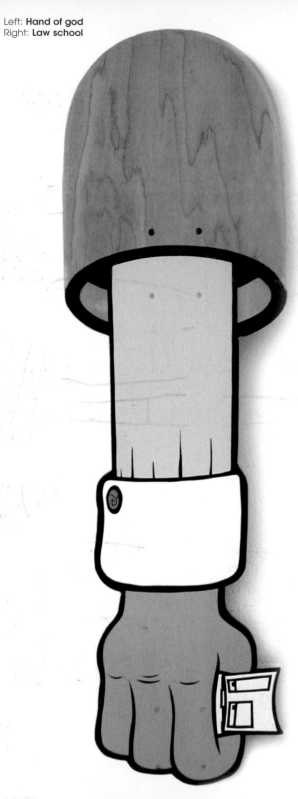

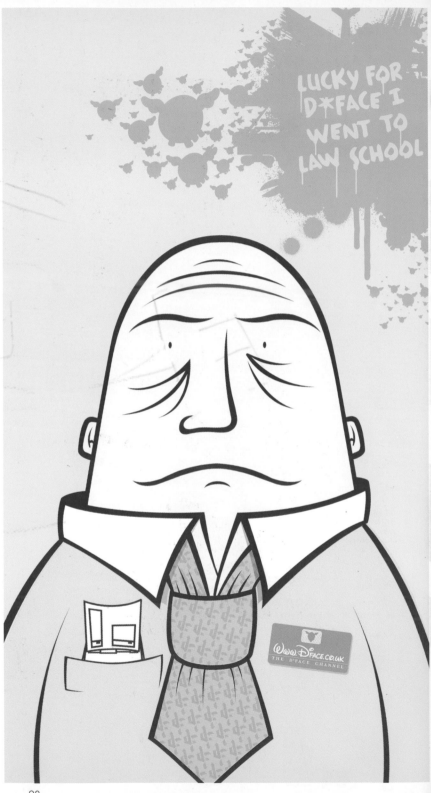

LUCKY FOR
D*FACE I
WENT TO
LAW SCHOOL

www.D*FACE.CO.uk
THE D*FACE CHANNEL

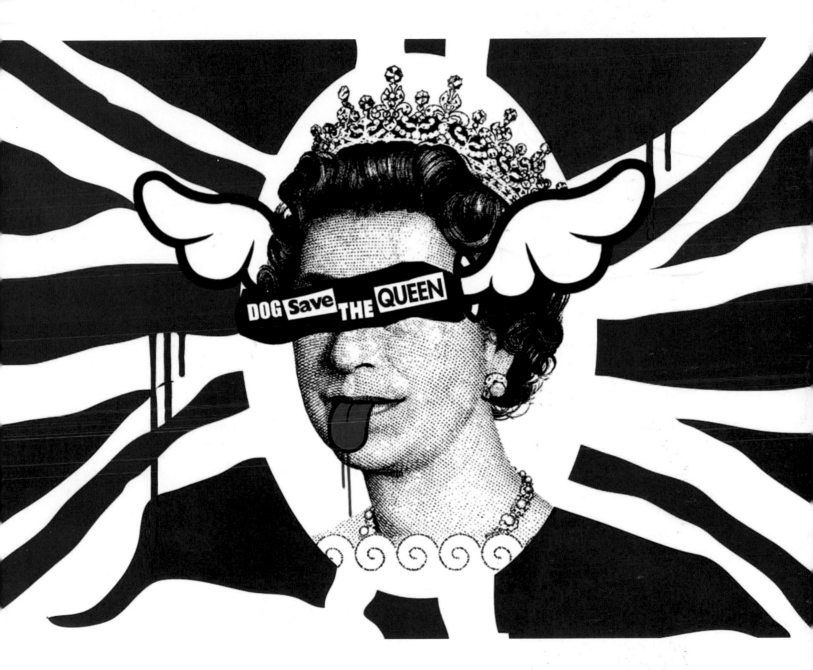

Above: **Dog save the Queen**

D*Face

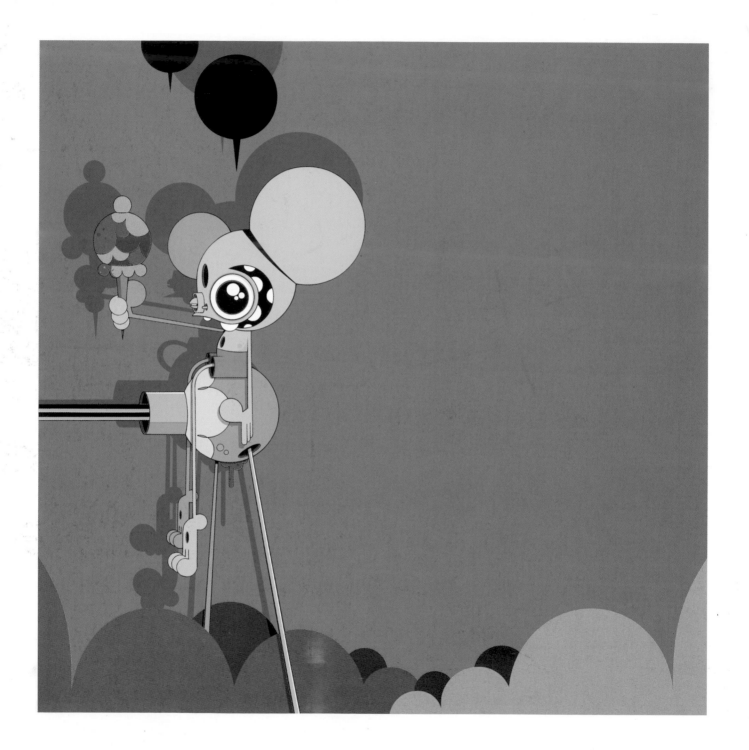

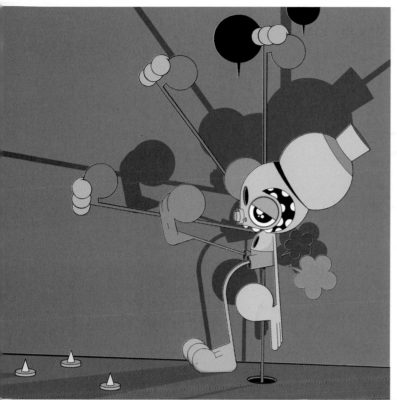
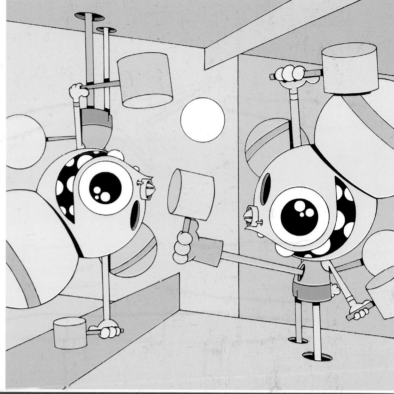

Dalek

Dalek a.k.a. James Marshall lives in Brooklyn and has been skating since 1984.

Skateboarding has played a profound role in my life and in my creative drive. My first artistic inspiration was Pushead. That's why I rode Zorlacs, he did all the graphics. It made me want to draw all the time, and I did.

Although a respected graffiti artist, he now works predominantly in acrylics, painstakingly drawing his 'Space Monkey' characters with clean lines and bold colours. These trademark characters are amusing and disturbing in equal measure, and always maintain a sinister smile despite their often self-inflicted injuries. The Space Monkeys were born out of a childhood obsession with cartoons and the occasional head injury. He has exhibited widely throughout the US, Europe and Japan, as part of group and solo shows. He has also produced graphics for Rookie Skateboards.

http://www.dalekart.com

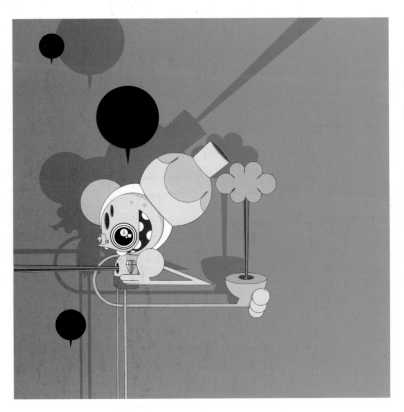 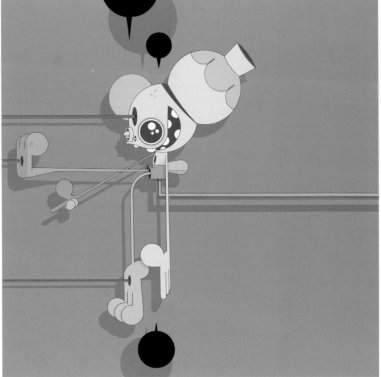

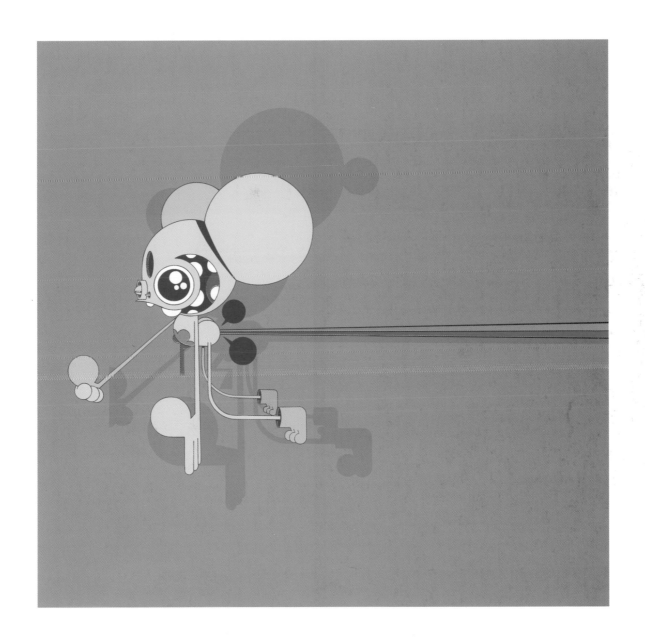

Dalek

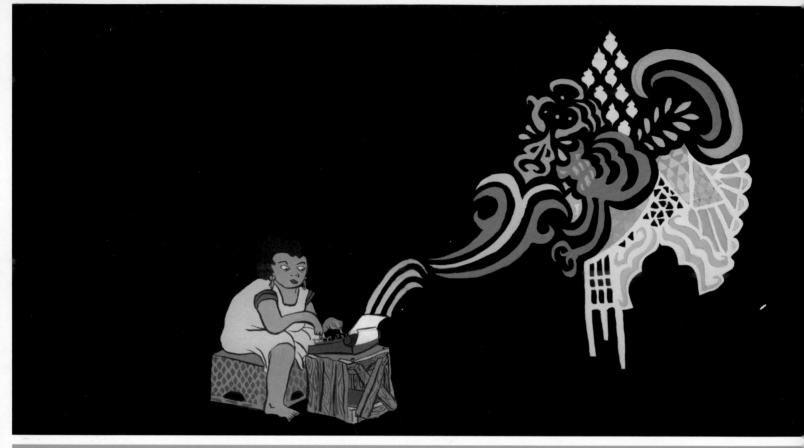

Lori Damiano

Lori D is an artist, animator and film-maker from California, now living in Vancouver, Canada. She is a member of the notorious Villa Villa Cola female skateboarder collective that has recently produced the much acclaimed film Getting Nowhere Faster showcasing the high level of skill and ability present in women's skateboarding, and featuring Lori's animations. Lori obtained a BA in film and video at the University of California, San Diego, and studied for a year in Australia before completing a Masters degree in experimental animation at the California Institute of the Arts. She mostly uses acrylic paint on wood or canvas to produce her artwork.

Looking for situations or people to paint helps me to practise awareness and as a result I get to become better acquainted with the universe's charm bracelet.

http://www.villavillacola.com

Above: **Reinvent typist**
Right: **Raft**

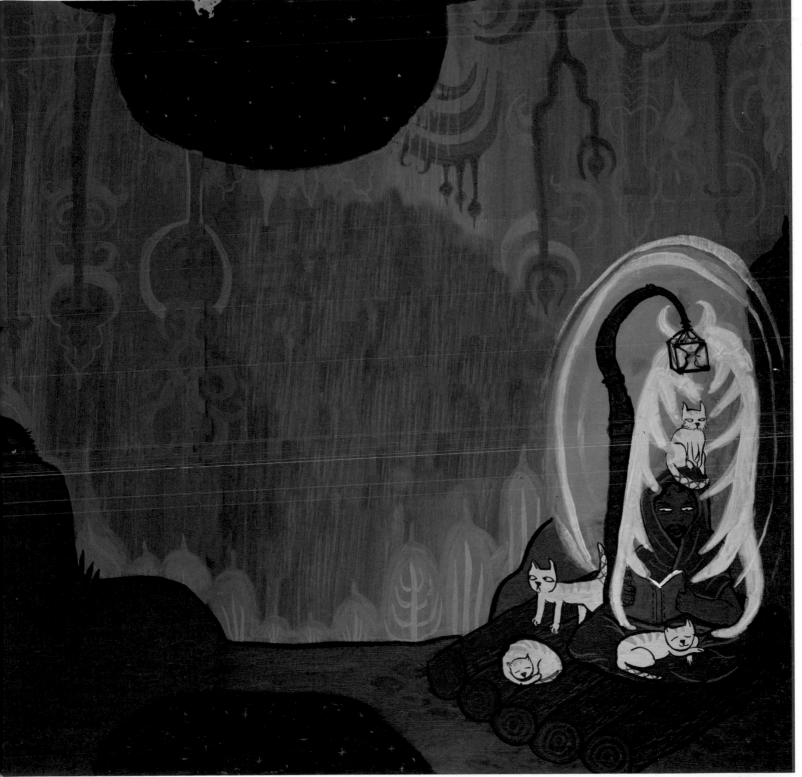

Lori Damiano

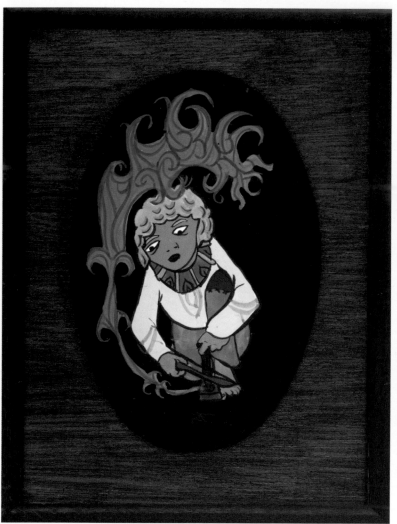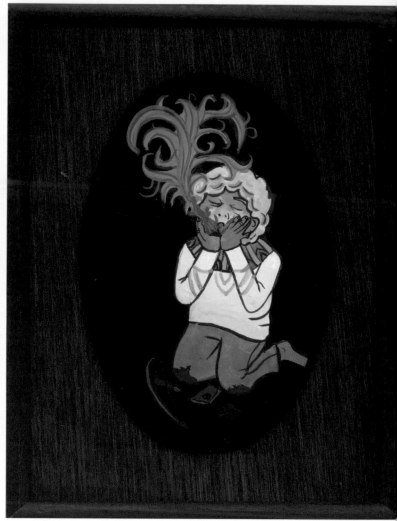

Above left: **Firestarter one**
Above right: **Firestarter two**

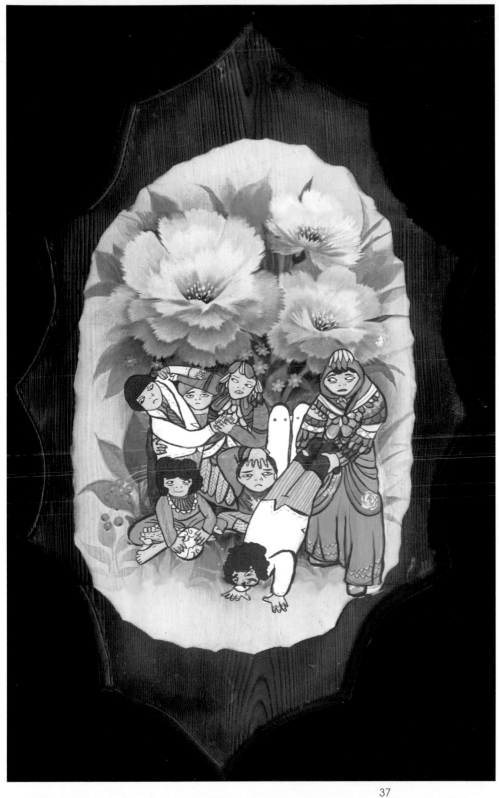

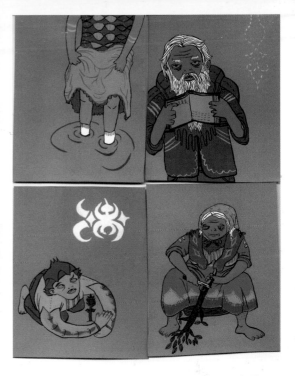

Top: **Green four**
Above: **Marching band**
Left: **Flower people**

Lori Damiano

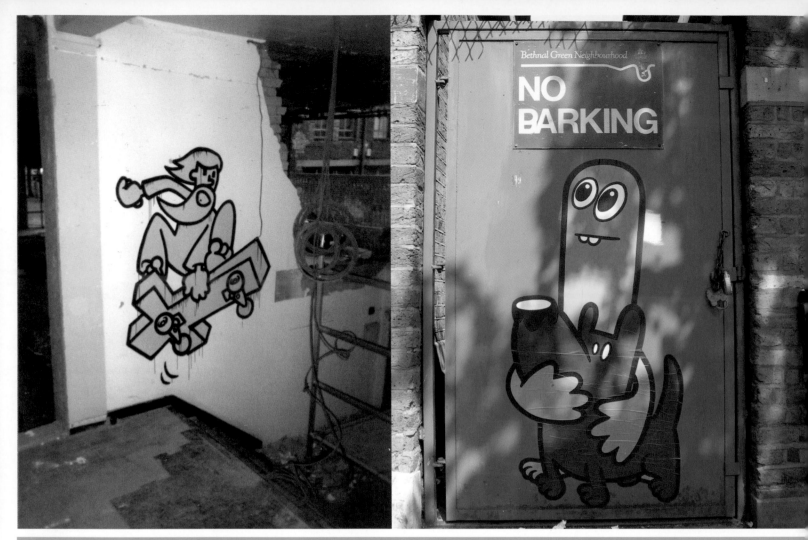

Dave the Chimp

Dave the Chimp is an artist, designer and illustrator from London. He is also a respected street artist and his colourful array of characters can be spotted on and around the streets of east London. He designs graphics for German-based Hessenmob Skateboards and has been involved in exhibitions throughout the UK and Europe. Chimp first stepped on a skateboard nearly 20 years ago, and with no local skatepark he began searching out skate spots with his friends, looking for any curbs, steps and ledges they could find. 'Searching for spots was part of the adventure, and our eyes were constantly open, always looking for every opportunity, no matter how small.'

He moved to London in the late 1990s and began to meet other skaters who were also graffiti writers. Chimp began his own brand of character-driven graffiti six years ago, using household paint, sprays and pre-painted posters to leave his mark. He explains how his art has been influenced by his thinking as a skateboarder: 'I like to make my art integrate into the world around it, use the available architecture as part of the painting, see opportunities regular people wouldn't even notice. Just like a skateboarder does every time they leave the house.'

http://www.243support.com
http://www.visualrockstars.com

Above left: **Extreme Jesus stair jump**
Above right: **No barking**

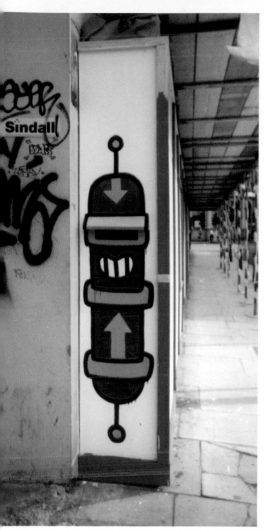

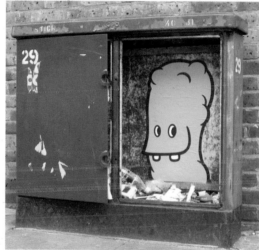

Far left: **Robot letter box**
Above: **Basement monster**
Left: **What lurks in those green boxes**
Below left: **Building site robot**
Below right: **Pirate harbour**

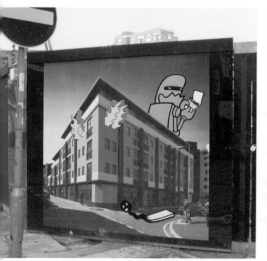

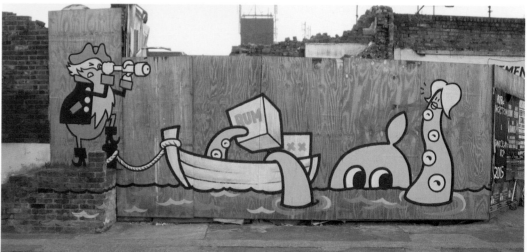

Dave the Chimp

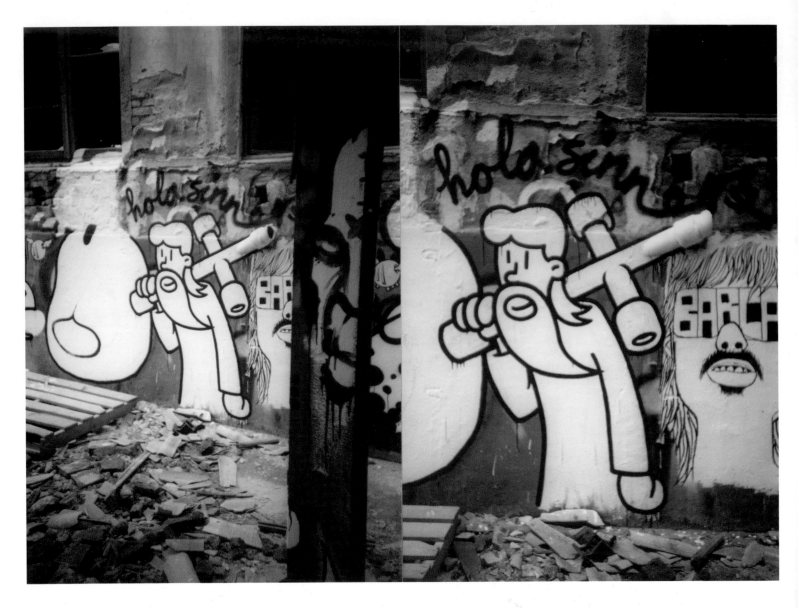

Above: **Extreme Jesus 02**
Opposite page: **Extreme Jesus 03**

Dave the Chimp

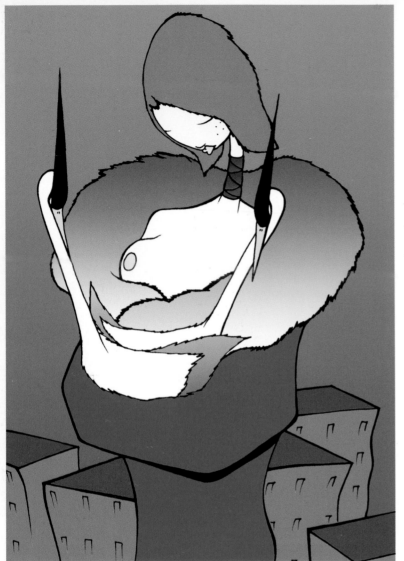

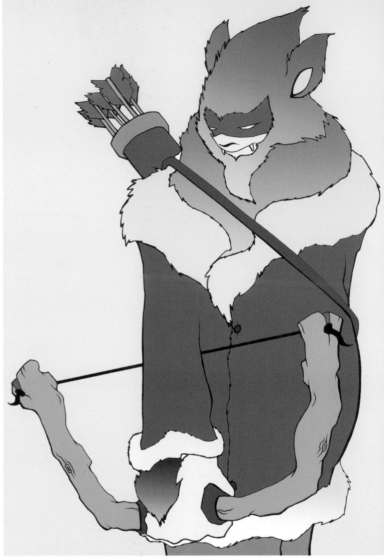

David Earl Dixon

David Earl Dixon a.k.a. Dist.One uses a variety of materials for his work: 'Just whatever I can lay my hands on, all paint, all computers. I'll take anything, tester pots, crappy cans of primer. My wife knows I just always go through loads of materials so she just picks up whatever, acrylics, gouache, emulsion.' As well as doing digital design he is also a street artist, painting and pasting his distinctive cast of characters around his hometown of Colchester.

All my street stuff is an attempt to hint at a deeper world below, like scratches on the surface. People see little characters dotted around and hopefully they are like 'neat', and they get psyched and are

intrigued to find out more. I don't really care much for the 'Up's' battles that go on, I just go at my own little pace.

David is currently art director for The Harmony, a new UK skate company that will be featuring his unique work on its boards.

http://www.distone.co.uk
http://www.theharmony.co.uk

Above left: **Cranelady**
Above right: **Wolfsbane**

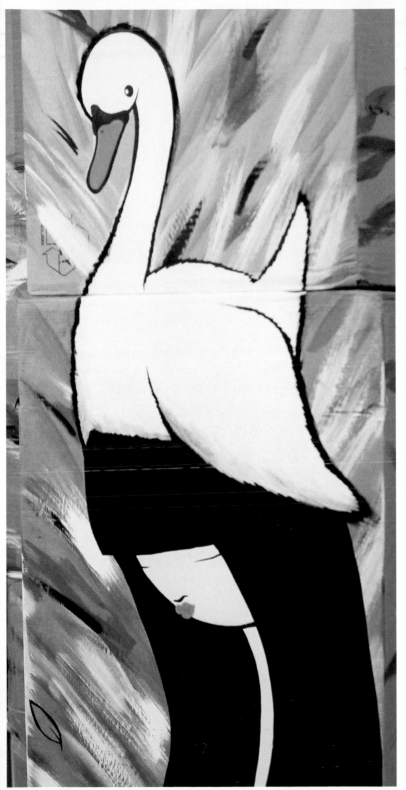

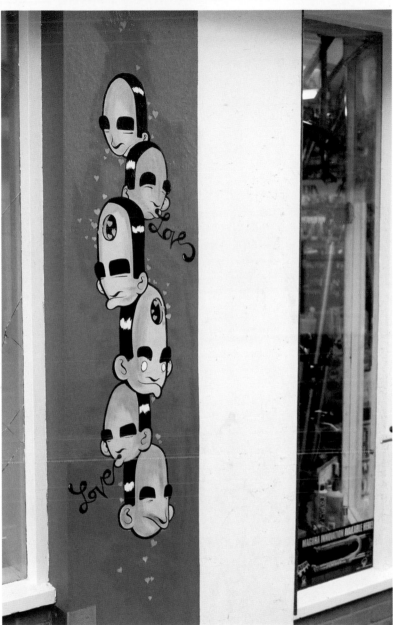

Left: **Swan**
Above: **Love**

David Earl Dixon

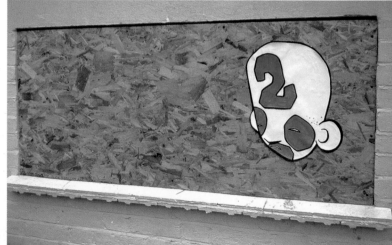

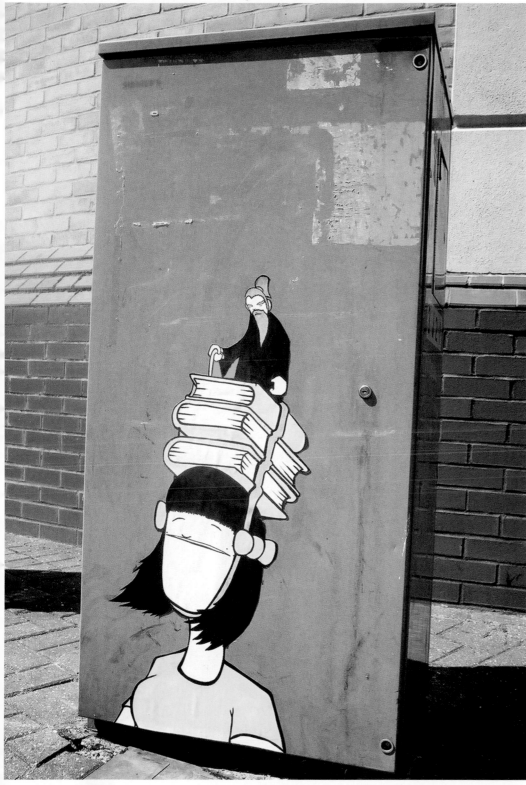

Opposite page: **Circus of the forty thieves**
Left: **Learning posture**

45

David Earl Dixon

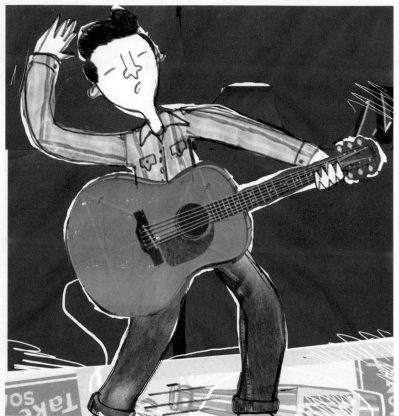

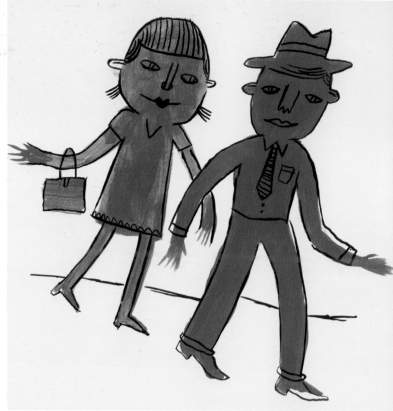

Max Estes

'Skateboarding has always been more than just kicking around on a piece of wood,' says artist and illustrator Max Estes from Milwaukee.

Skateboarding has virtually schooled millions of kids like me in the visual arts. Growing up in a small Midwest American town, skateboarding was our vital 'link' to the big cities, providing a much-needed escape from small-town mentalities. As kids we saw Meccas like New York and San Francisco churn out hybrid art movements and new music genres where skateboarders were often the pioneers.

Outside of skateboarding Max is influenced by American folk artists such as Howard Finster and contemporary cartoonists including Jeffrey

Brown and Brian Ralph, and he mostly writes and illustrates stories about the day-to-day lives of the 'everyman'. His first graphic novel, entitled Hello, Again, was published in March 2005. Max's current work focuses on painting, and uses found wood such as small tree trunks and sections of branches as canvases: 'I'm interested in the melding of organic objects and graphic, refined paintings.'

http://www.maxestes.com

Above left: **Cowboy**
Above right: **Night on the town**

Clockwise from left:
Cat food
Pepper can
Ballpark sketch 01
Ballpark sketch 02

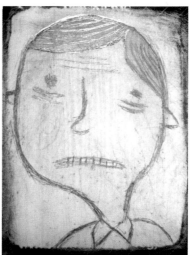

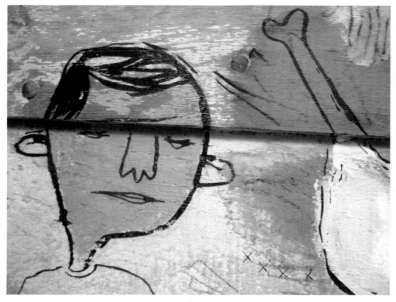

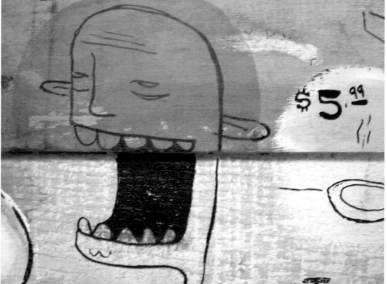

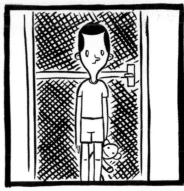

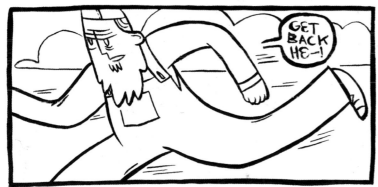
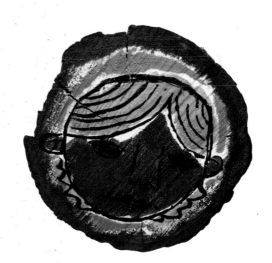

Above: **On the fence**

Max Estes

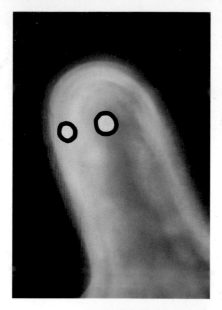

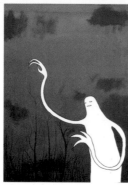

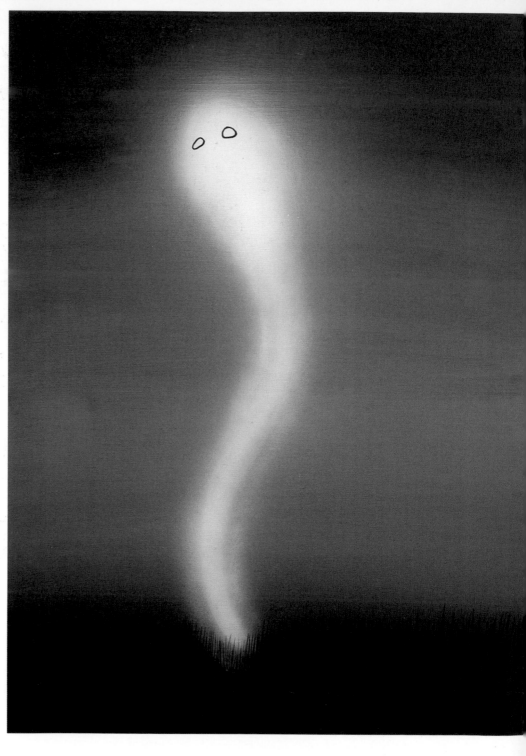

Top: **Ghost**
Above: **Hands ghost**
Right: **Field ghost**

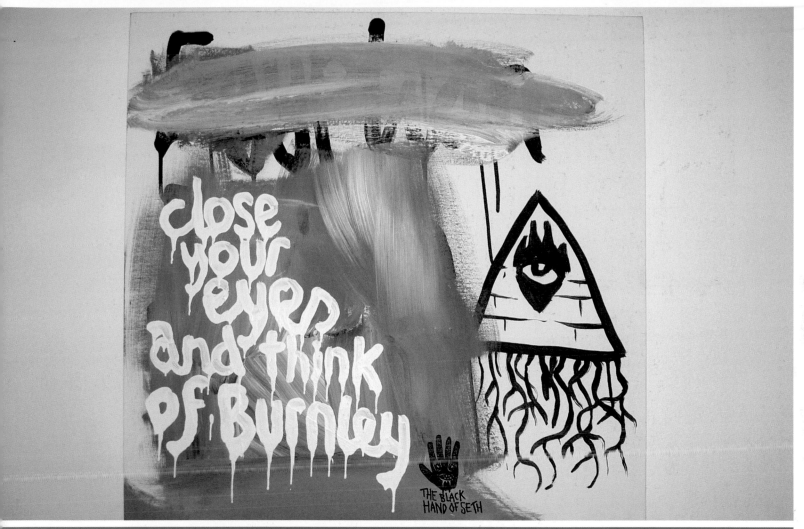

The black hand of seth

close your eyes and think of Burnley

Mark 'Fos' Foster

Fos founded UK skate company Heroin Skateboards in 1999, and his distinctive, scratchy sketches have appeared on their boards ever since. He has also produced graphics for Toy Machine, and runs Landscape Skateboards, a sister company of Heroin. Known for his love of black coffee and the music of Tom Waits, Fos lists his inspirations as music, film, friends and travel. He always carries his sketchbook with him, and nearly all of the graphics he produces have started from an idea in pen and paper.

http://www.heroinskateboarding.com
http://www.landscapeskateboards.com

Above: **Burnley**

Above: **Red bean bun**
Below: **Ruination**

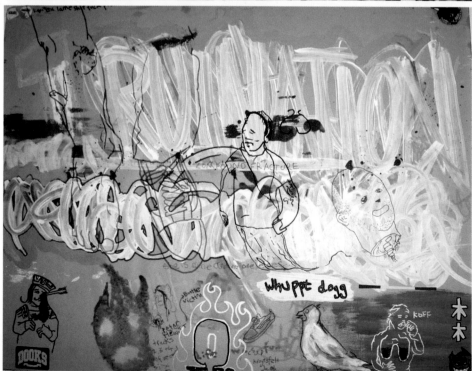

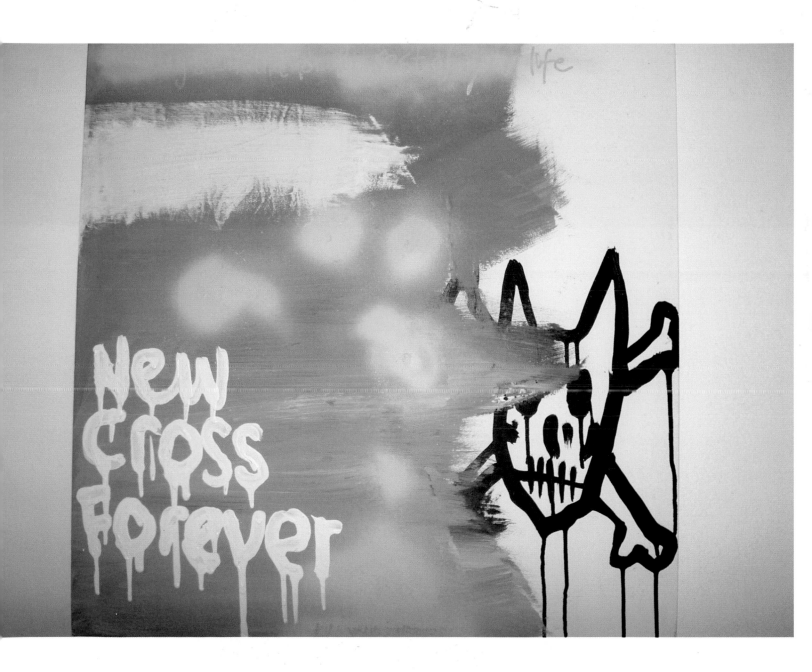

Above: **New Cross**

Mark 'Fos' Foster

Andy Howell

Andy Howell became a pro skater in 1989, the same year that he obtained a degree in visual communications from the Art Institute in Atlanta. He skated professionally until 1995, and during this time he co-founded several influential skateboard companies, including New Deal Skateboards, which is credited with introducing graffiti-inspired art to skateboard and clothing graphics, 411 Video Magazine and Element Skateboards. He has exhibited his striking illustrations and fine art in New York, Los Angeles, Philadelphia, London and Tokyo.

http://www.andyhowell.com

Above: **Angel writing**

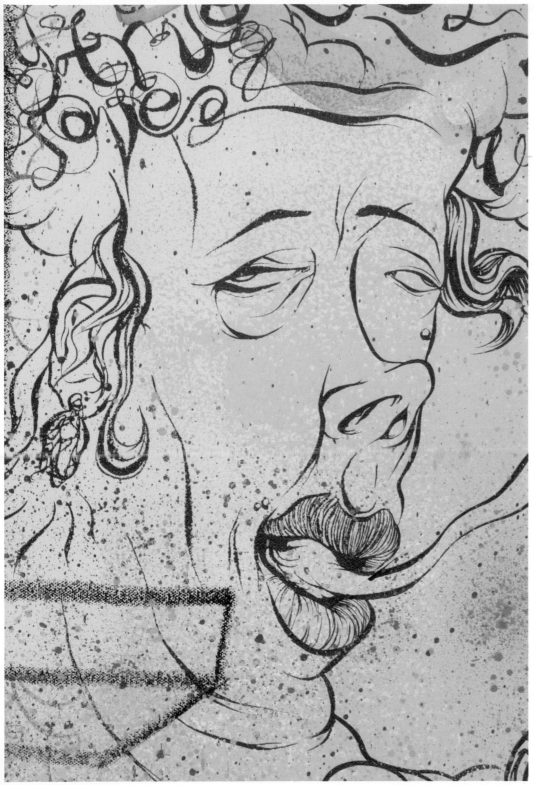

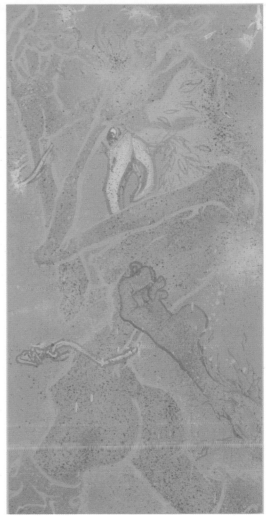

Above: **She became a phoenix**
Left: **Starcatcher** (detail)

Andy Howell

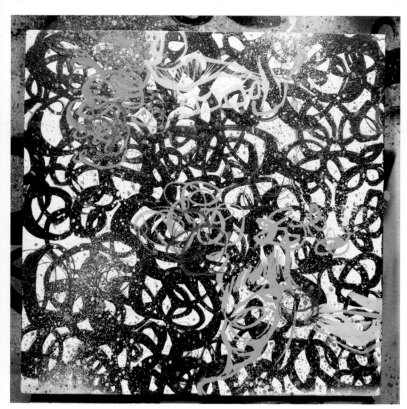
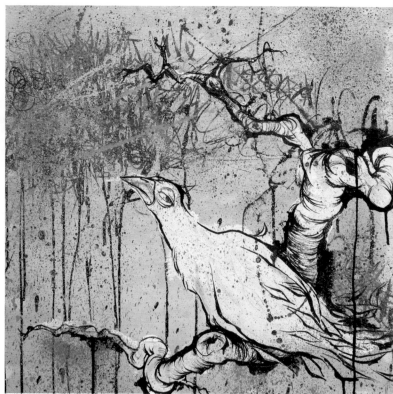

Above left: **Noise annoys**
Above right: **Birds life**

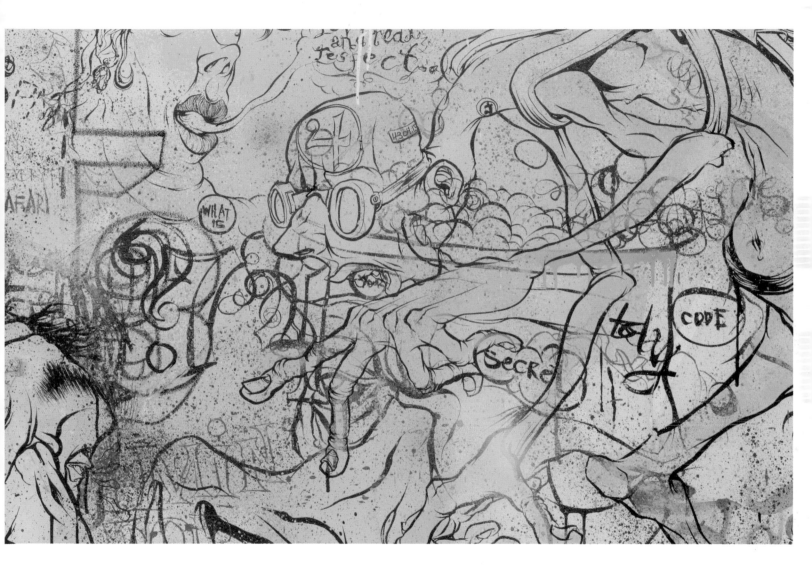

Above: **Starcatcher** (detail)

Andy Howell

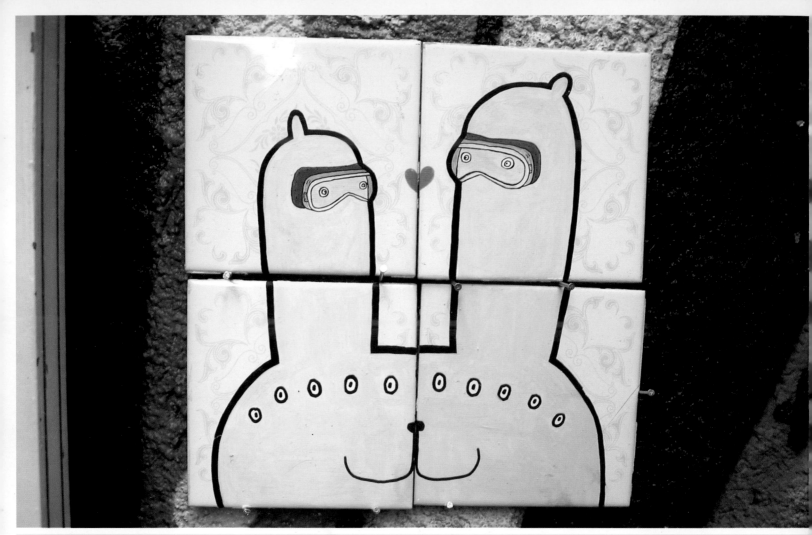

Ichi the Bunny

Ichi the Bunny is a street artist and film-maker from Japan. She came to London in 1996 to meet new people to make films with. She is also the creator of 'Bunny Jump', a series of handmade comics all based on true stories about Ichi and her friends. Ichi uses acrylic and spray paint to produce her art but her favourite medium is pencil. She first became interested in art as a child:

> At around six years old I started doodling with a pen, then started making comics at age eight. My parents refused to buy any comics for me, so I had to make ones for myself, for reading.

Ichi's unique and surreal animal characters can be seen on and around the streets of Shoreditch in London. Her inspirations include comic artist Taiyo Matsumoto and artist Egon Schiele.

http://www.243support.com

Above: **Love bunny**

Ichi the Bunny

 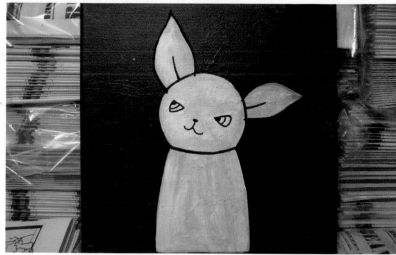

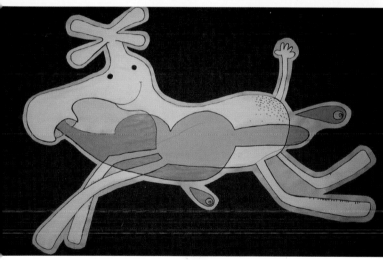 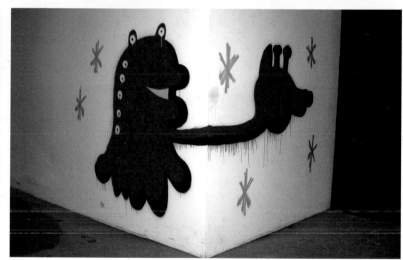

Clockwise from top left:
Punch bunny, Cheeky bunny, Monster giraffe, Water giraffe

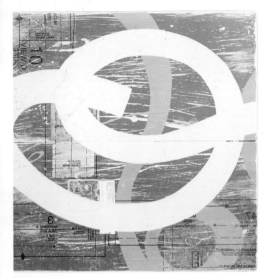

Andy Jenkins

Andy Jenkins is the art director at Girl Skateboards, heading up the
Art Dump, and is an artist, graphic designer, illustrator and publisher.
He spent seven years working for various magazines, where he was
writing, illustrating and designing. In 1994 he started working for Girl
Skateboards. He has produced hundreds of board graphics over the
years for Girl, Chocolate, Hessenmob, World Industries and Blind. His
personal work, which includes illustration and mixed media on canvas,
has been exhibited widely across the US, in Australia, Europe and
Japan, as part of solo and group shows. He also runs Bend Press,
which is a small, independent publishing company that began life
as a self-published skate/punk zine.

http://www.bendpress.com
http://www.girlskateboards.com

Spread: **Ugly beauty paintings**

Andy Jenkins

Andy Jenkins

"keep an eye out for it."

- m.i.

"i'm committed to
seeing it through
one way or another."

- d.p.

Bob Kronbauer

Bob Kronbauer runs Crownfarmer, a clothing range that started as a side project while he was working at Girl Skateboards' Art Dump. He recently moved back to his native Canada to run Crownfarmer full time. Bob is a graphic designer and photographer, and in 2004 had Beach Glass published, a book containing photographs he took over three years while living in Los Angeles. He has contributed to many magazines, including Arkitip, Lodown and Skateboarder, and has designed skateboard and T-shirt graphics while working at Girl, as well as being the chief designer for Crownfarmer.

The relationship that I have with skateboarding is a lot like my relationship with the creative side of my brain. It's always been something that's helped to keep me somewhat sane and happy with my life.

http://www.crownfarmer.com

"the up side is that people will definitely see it."

- m.l.

"let me talk to you tomorrow"

- P.m.

Bob Kronbauer

Randy Laybourne

Randy Laybourne was born in Ontario, Canada and grew up in a small town on the west coast of British Columbia. He began drawing from a young age and pursued art throughout high school and college. He began skateboarding in 1986 as it fitted naturally with his already creative and unconventional approach to life. After travelling round Europe with a skateboard for a year in 1992, he returned to Canada to pursue degrees in art and design, and eventually began working creatively within the skateboard industry, most notably for Emerica and

Giant Skateboard Distribution. Now based in California, he has been a freelance designer since 2003. Randy says he is currently 'Moving forward from the struggles in life and focusing on doing art that entertains and gets across my personality. Sarcasm runs high.'

http://www.lookforwardtothepast.com

KEEP
on
THE
Move

Randy Laybourne

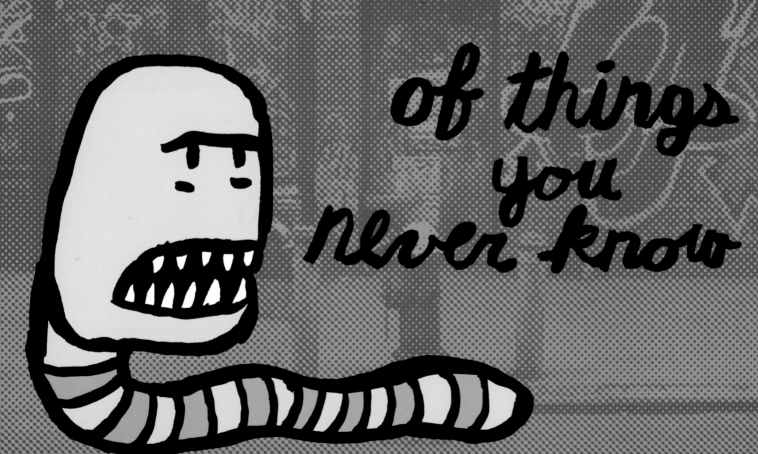

Above: **Skull print**

Michael Leon

Michael Leon is an artist and graphic designer. He previously worked for Girl Skateboards but now runs his own design and clothing company Commonwealth Stacks Conversation Editions with his wife Laura. He has produced board graphics for Girl and Element, and art directed for Rasa Libre. In 2003 Michael created the fictional skate brand Some Girls for an exhibition at a boutique called Red Five in San Francisco. The unique products he created for Some Girls were only available for the duration of the show. Michael has also exhibited his work in solo shows in the US, Europe, Canada and Japan, and has collaborated with companies such as Nike, Stussy and DC. At the core of his work lies freedom of expression and the DIY attitude inherent in skateboarding.

http://www.commonwealthstacks.com

Left: **California silk screen print**
Above: **Silk screen on found poster**

Michael Leon

Michael Leon

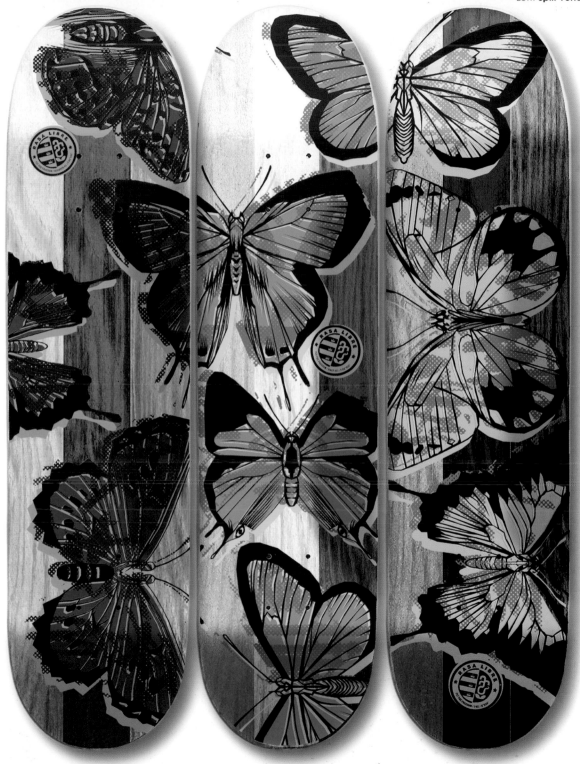

Michael Leon

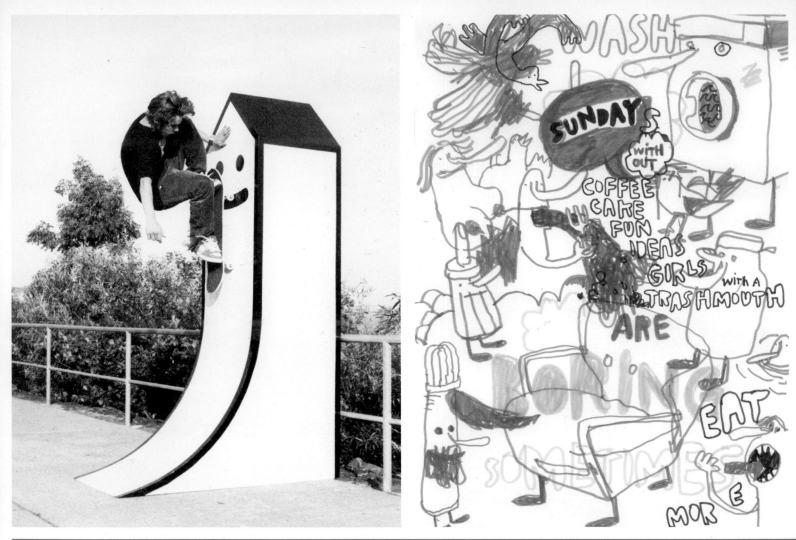

Stefan Marx

Stefan Marx is an artist and designer from Hamburg, Germany. From there he runs The Lousy Livin Company, designing and producing limited-edition T-shirts. Stefan has also created T-shirts and board graphics for Hessenmob Skateboards, and has contributed artwork for exhibitions in London and Europe. Stefan also constructs large 'skate-able characters', which are skateboard ramps presented as houses based on his unique illustrations. He creates intricate, intertwining, living cities where his fun and friendly characters reside. His most recent work is two board designs featuring his trademark graphic/illustrative style for skate company Cleptomanicx.

http://www.livincompany.de

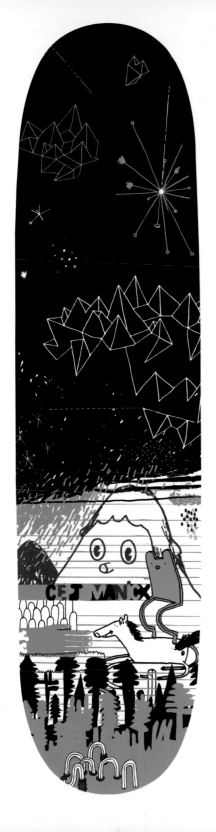

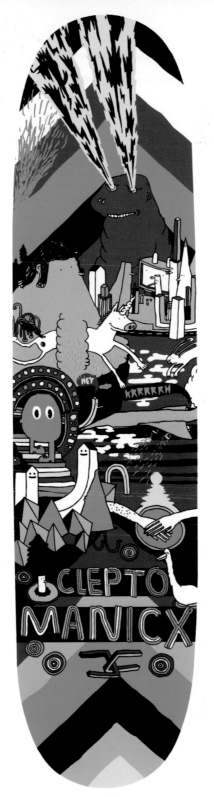

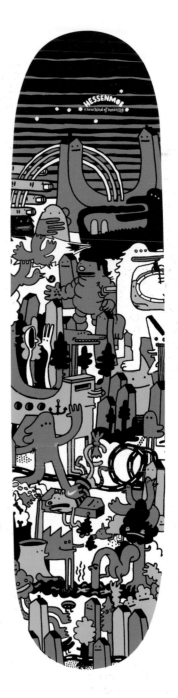

Left: **Cleptomanicx universe board**
Centre: **Cleptomanicx world board**
Above: **Hessenmob board**

Stefan Marx

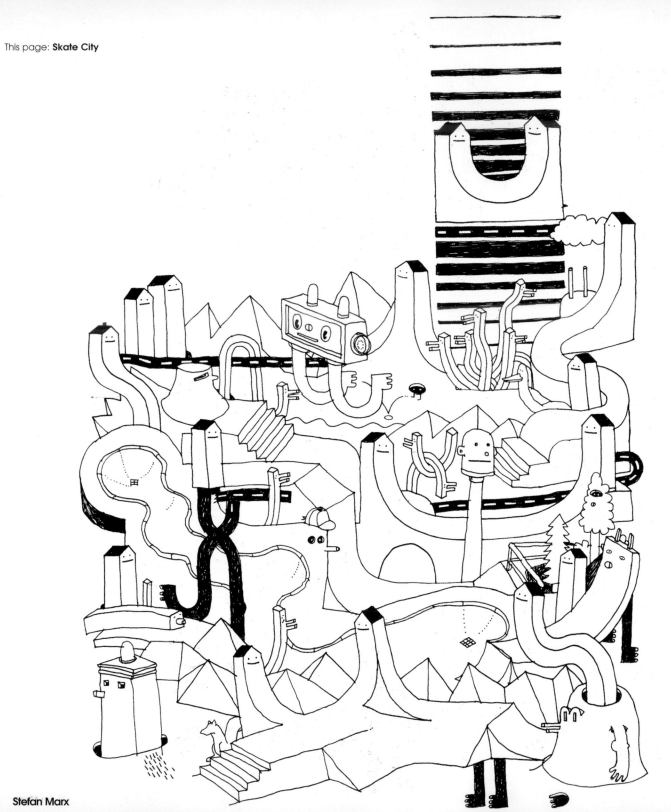

Stefan Marx

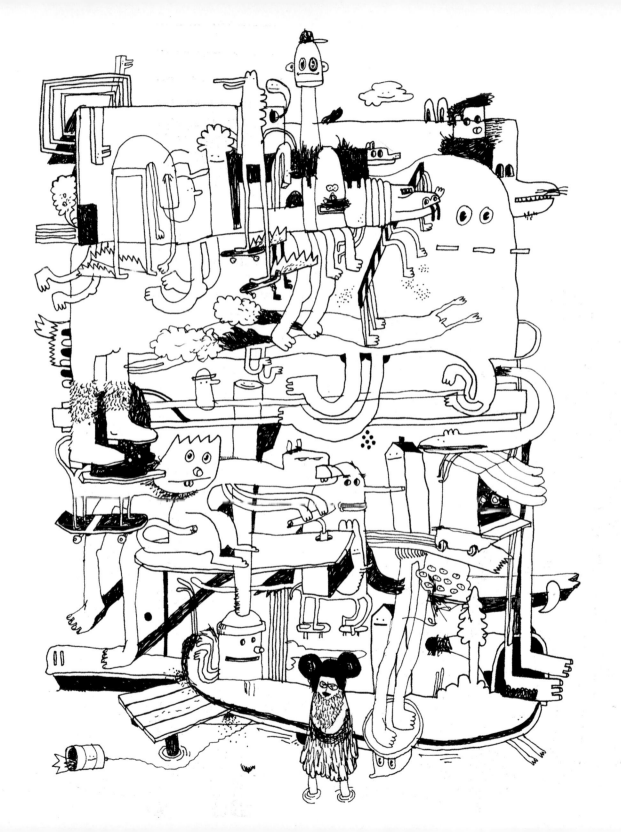

Stefan Marx

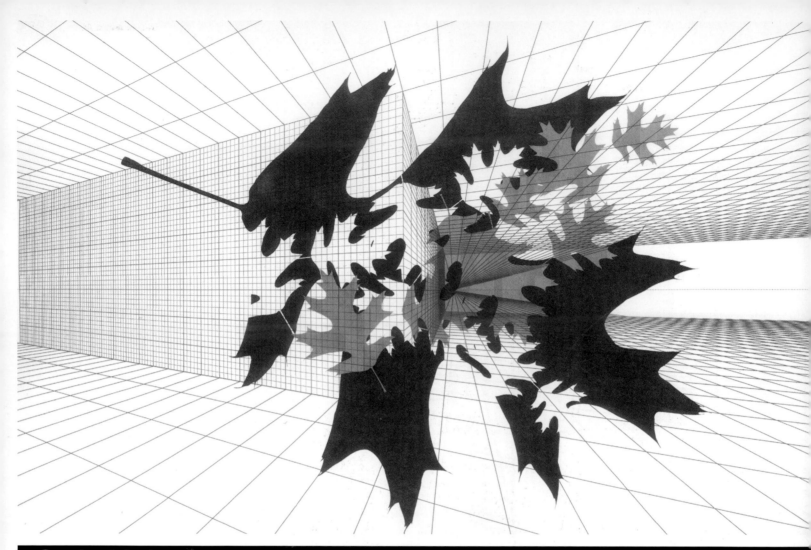

Craig Metzger

Craig Metzger recently left New York for the West Coast, moving to Los Angeles. He has no formal art training and his work consists of illustrations, hand-cut paper, and acrylic paint and silk screens mainly on wood and paper. He has worked extensively within the skateboard industry producing work for companies including éS, Etnies, Emerica and 5Boro, as well as for companies such as Nike and MTV. Craig has exhibited internationally in solo and group shows and recently launched his own skate company, Instant Winner.

http://www.enginesystem.com
http://www.theinstantwinner.com

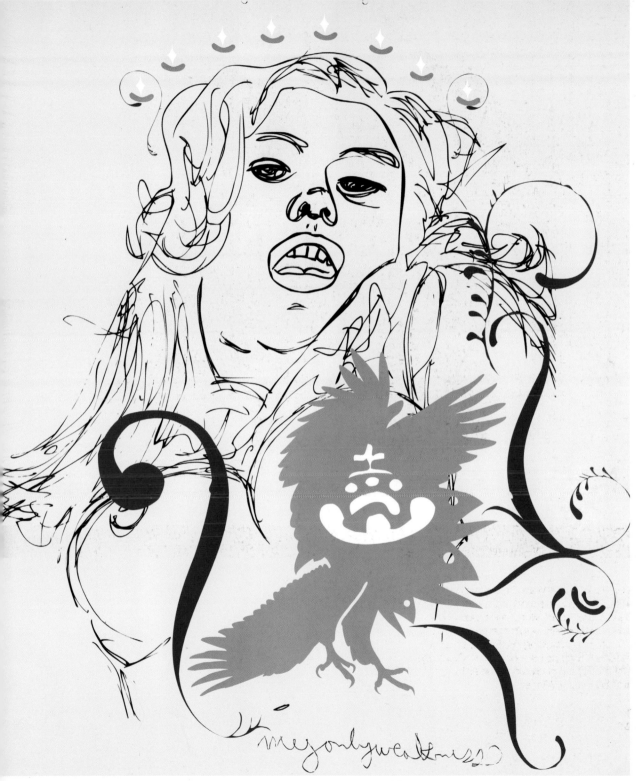

Craig Metzger

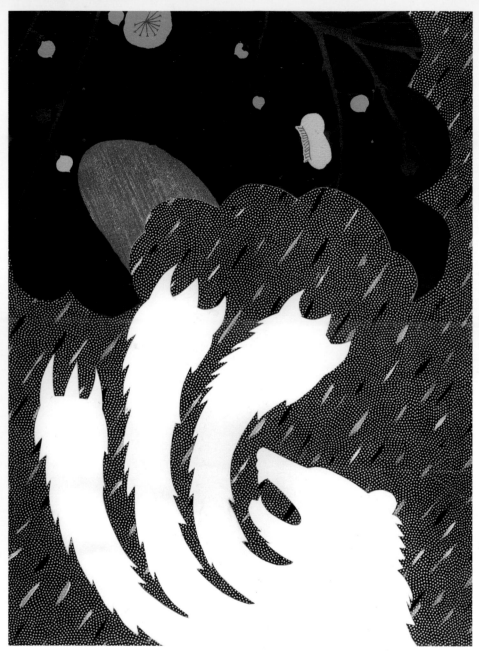

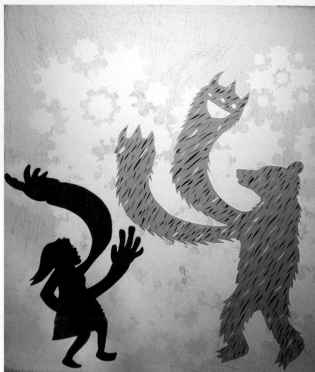

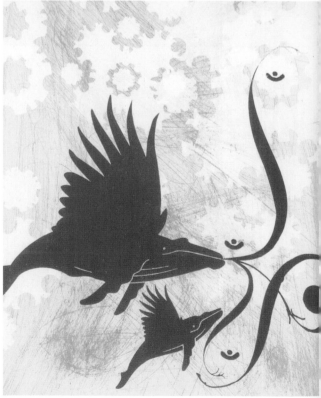

Above: **Feudal Japan**
Above right: **Fairytale gone bad**
Right: **Halls of milstein**

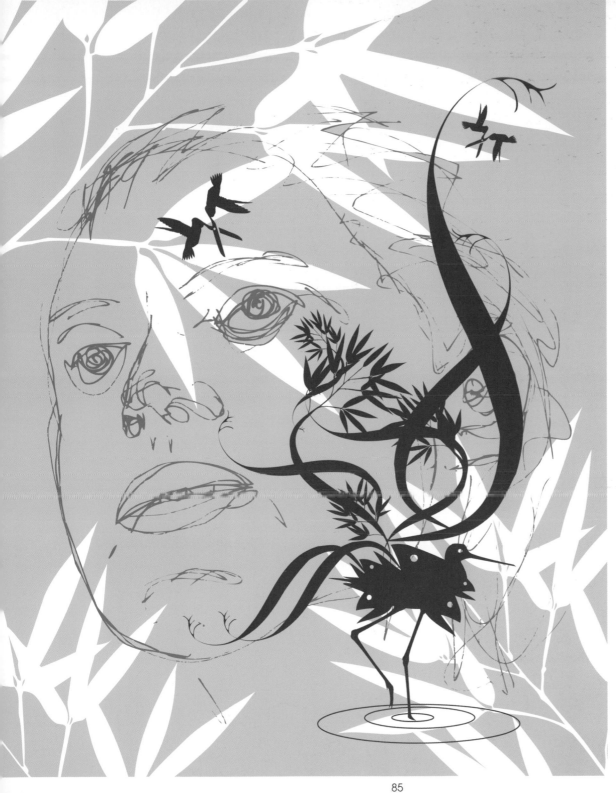

Craig Metzger

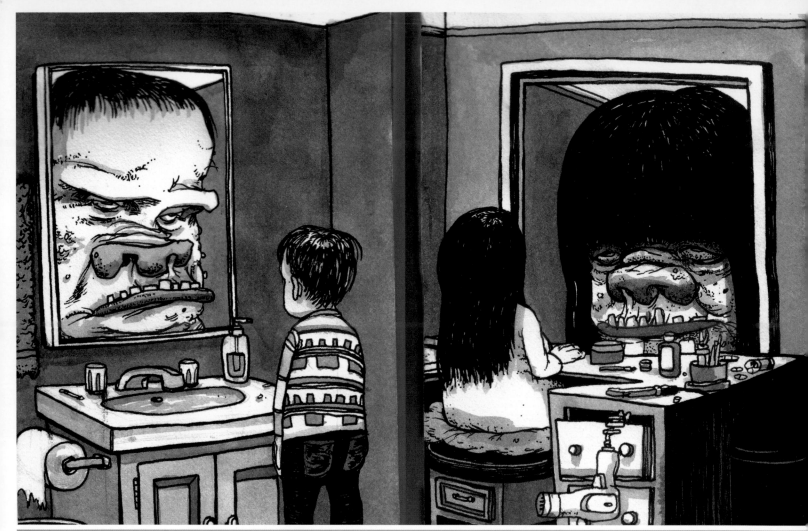

Travis Millard

Travis Millard is the proprietor of Fudge Factory Comics, based in east Los Angeles, California. Travis's work covers a broad spectrum that includes comics, drawing, installation, product design, animation, illustration and limited-edition books. Travis lived in New York City before moving to his current home after being invited over to exhibit in a joint show with his friend and fellow artist Shepard Fairey. His distinctive pen-and-ink character-based illustrations have appeared in and on the covers of numerous magazines, including Slap and Spin. He has exhibited in group and solo shows across the US, including a solo show in his hometown of Lawrence, Kansas.

http://www.fudgefactorycomics.com

Above: **Mirror**
Opposite page: **Saws**

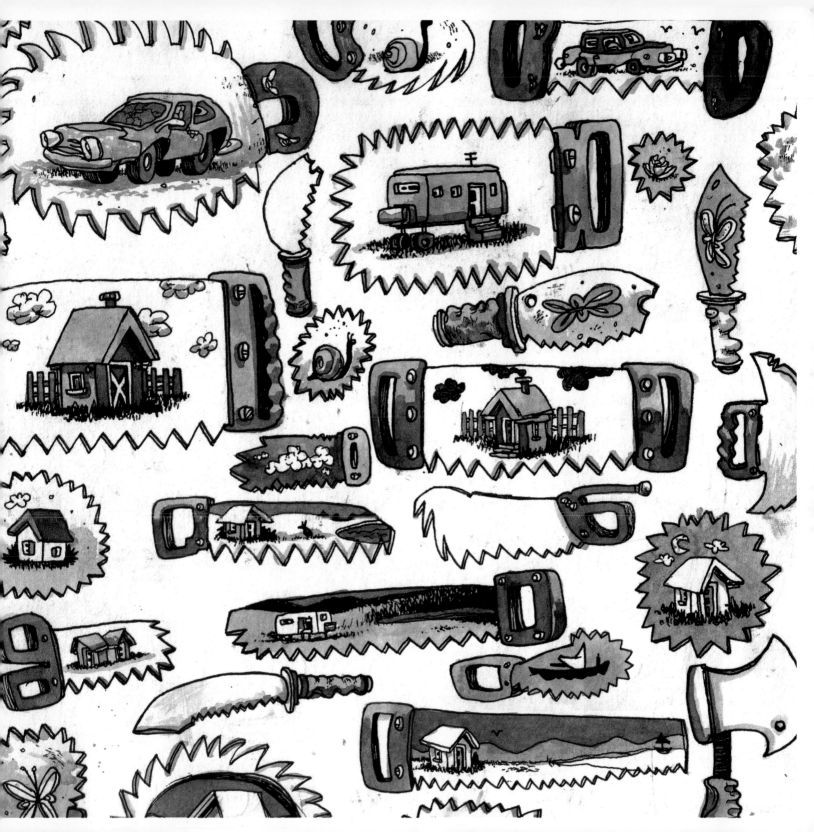

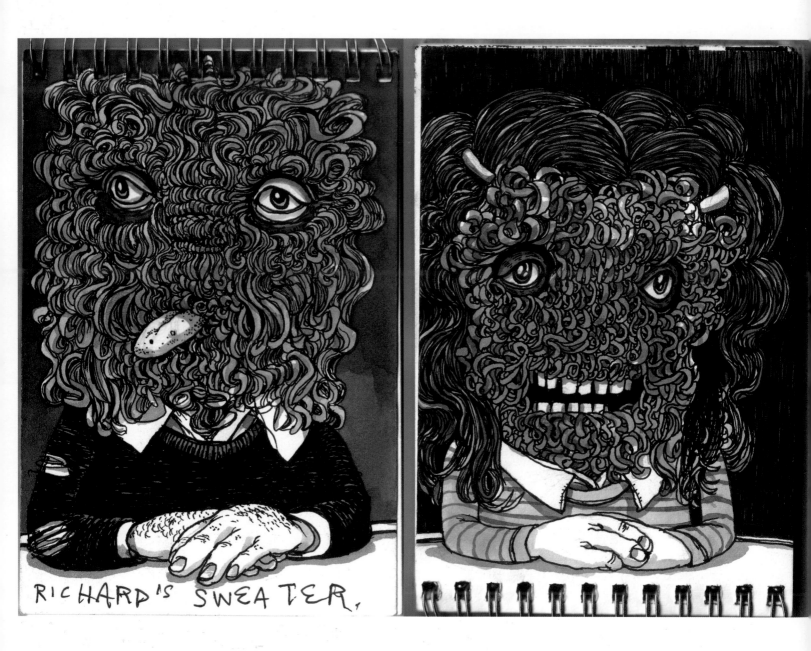

RICHARD'S SWEATER.

Above: **Hairy kids**
Opposite page: **Biz merge**

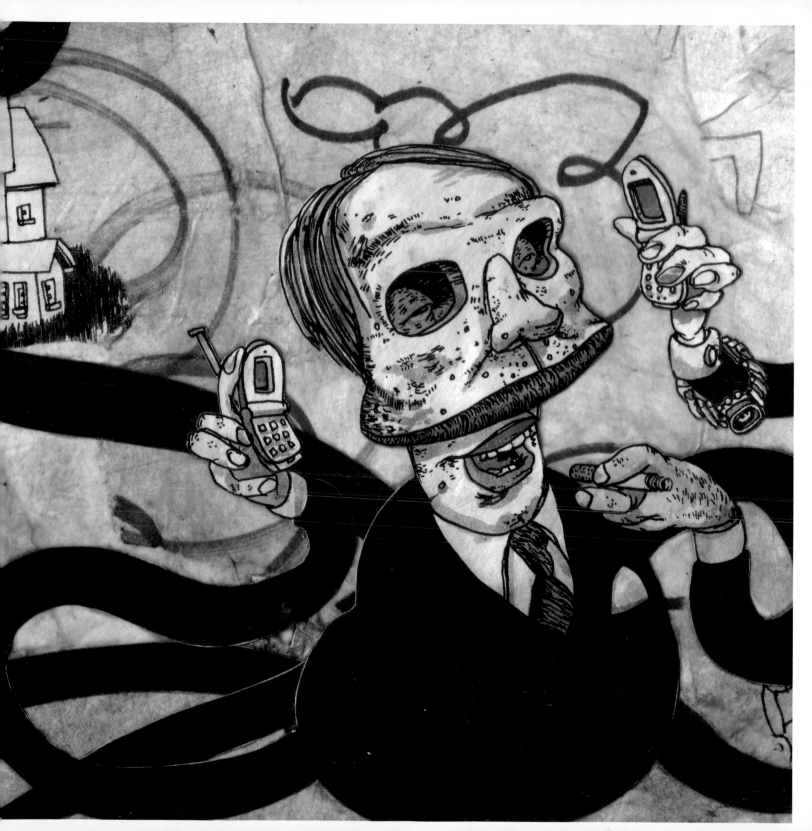

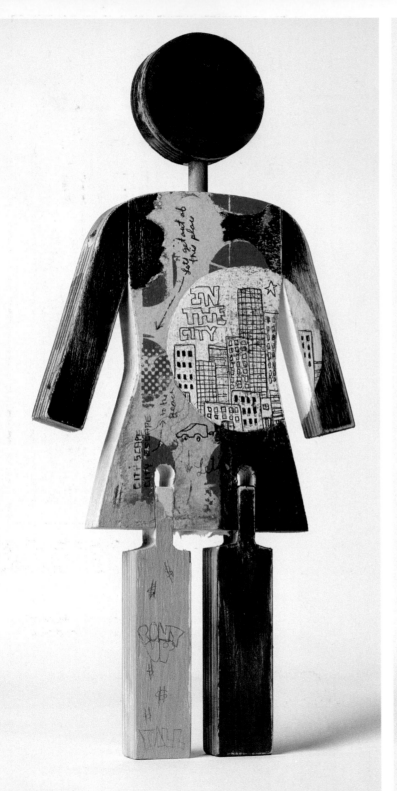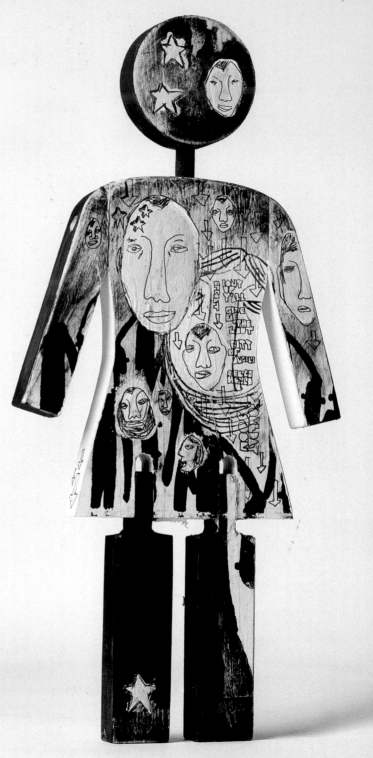

Andy Mueller

Andy Mueller

Andy Mueller lives in Los Angeles, where he works full time for Girl Skateboards as the art director of Lakai Shoes, part of the Girl Skateboards family. He also produces board graphics for Girl as a member of the Art Dump, alongside fellow artists Andy Jenkins and Rob Abeyta Jr. Interested in skateboarding, art and photography from an early age, Andy has been lucky enough to be able to combine these interests throughout his professional career. As well as his work for Girl, he works as a freelance designer and photographer for his own company, OhioGirl. In 1997 he began The Quiet Life, a side project that started as an outlet for his personal designs and doodles. Initially only producing a few new T-shirt graphics a year, it soon grew and now produces a full range of soft goods twice yearly.

http://www.thequietlife.com
http://www.ohiogirl.com
http://www.girlskateboards.com

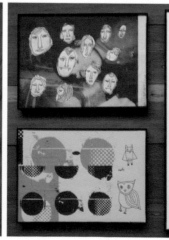

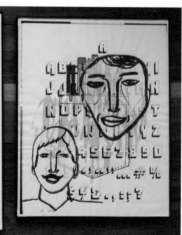

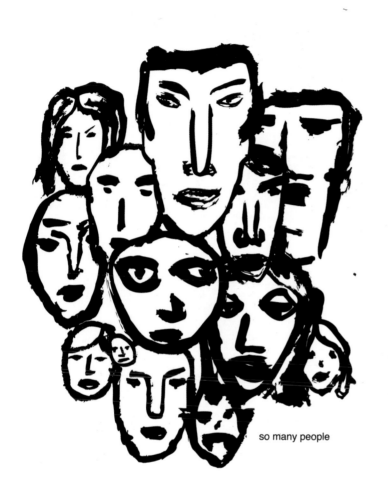

so many people

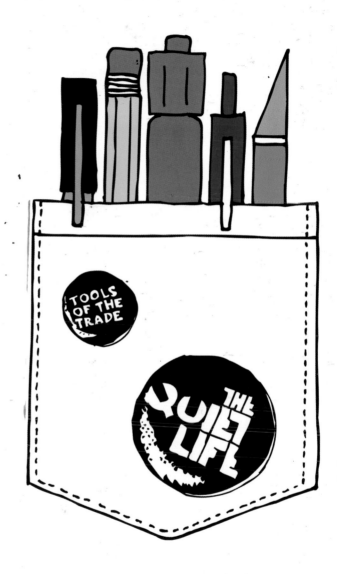

TOOLS OF THE TRADE

THE QUIET LIFE

Opposite page
Top: **Work in artist's studio**
Bottom: **Framed pieces**

This page: **Doodles for The Quiet Life**

Andy Mueller

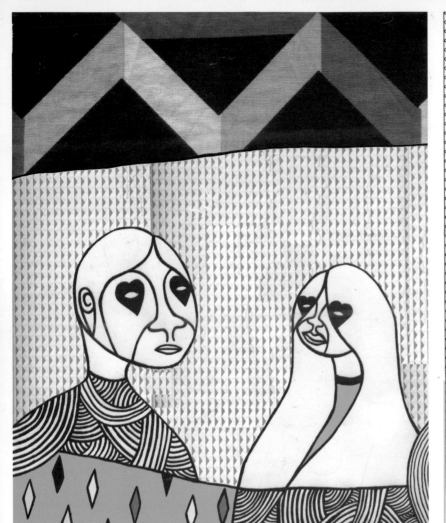

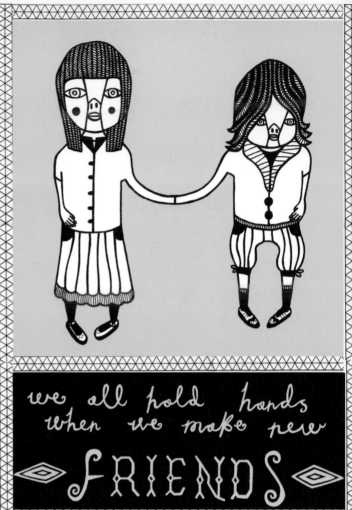

we all hold hands when we make new FRIENDS

Simon Peplow

At 21, Simon Peplow made the conscious decision not to pursue a career as a skateboarder but instead to concentrate on a degree in visual communications at the Birmingham Institute of Art and Design, where he obtained First Class honours in 2004.

I decided to just skate for fun and to follow a similar dream which offered far fewer bent, twisted and broken body parts. I began a new journey, which mainly focused on developing myself as an illustrator.

Earlier in 2004 he co-founded the Outcrowd Collective with fellow Birmingham-based artist Log Roper. Simon mainly uses pencil and an Edding Fineliner to create his works, with the occasional splash of paint.

He then scans them into his computer to adjust, re-colour and tidy up.

My work tends to be a bunch of whimsical ideas and fleeting thoughts from my subconscious, teamed with a range of characters who I wish were my friends.

Simon is inspired and fuelled to progress by the work of many artists including Thomas Campbell, Mark Gonzales, Ed Templeton, Twist, Henrik Drescher and Maya Hayuk.

http://www.outcrowdcollective.com
http://www.banjo.dircon.co.uk

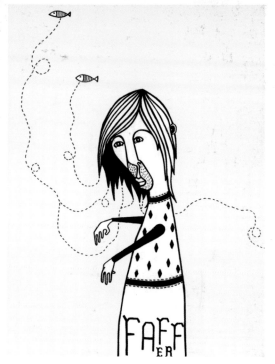

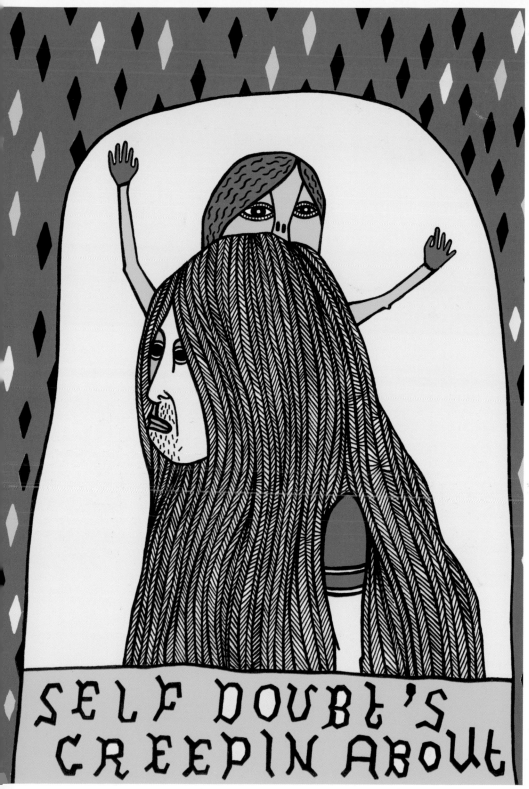

SELF DOUBT'S CREEPIN ABOUT

Opposite page
Left: **Don't mess with our love**
Right: **We all hold hands**

This page
Left: **Self doubt**
Above: **Faffer**

Simon Peplow

listen to folk music

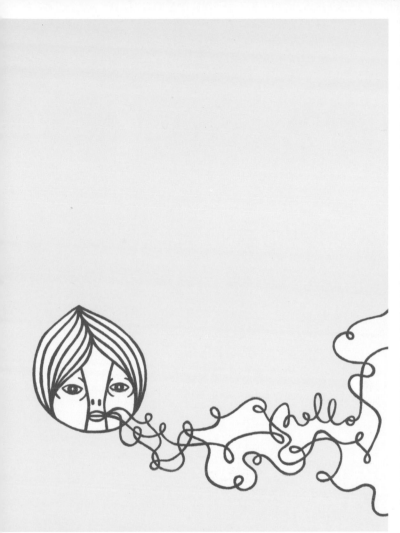

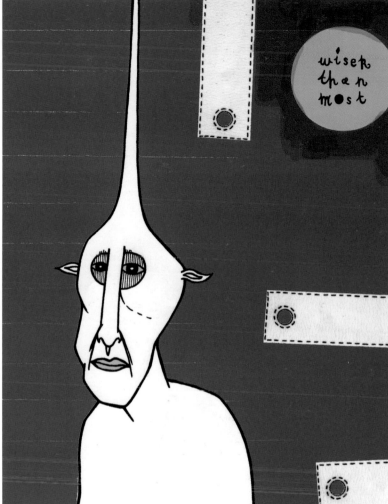

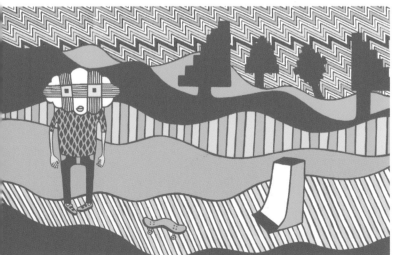

Opposite page:
Left: **Listen to folk music**
Right: **It's lonely here**

This page:
Above left: **Hello**
Above right: **Wiser than most!**
Left: **City dreamer**

97

Left: **Pointy**
Right: **Vamp**

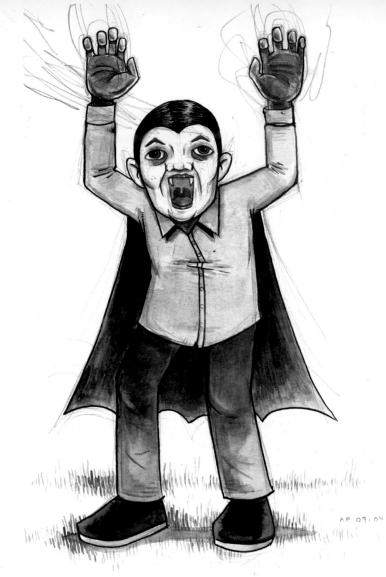

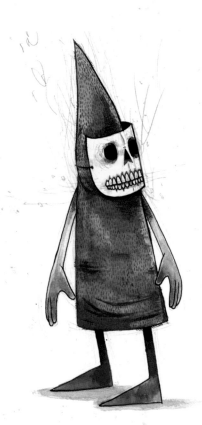

Andrew Pommier

Andrew Pommier is from Vancouver, Canada. His distinctive cast of misplaced outsiders is intriguing, amusing and sad. Often hiding in costumes, smoking and looking ill at ease, each character seems to have a story to tell. Andrew works in oils, watercolour and on computer. The images shown here are all in graphite, watercolour and ink on paper. His work has featured on board graphics for Toy Machine, and he has also provided graphics for the Momentum Wheel Company, Element, RVCA Clothing and Manik Skateboards. His first book, Things I Don't Remember, was published in 2004, and is a comprehensive collection of his work to date. He has exhibited in Toronto, Vancouver, San Francisco, New York, Munich and London. Andrew explains how skateboarding has influenced his work:

Skating exposed me to a lot of artists and influenced my work and how I draw. Just seeing what people did for graphics, like Neil Blender, Chris Miller, Lance Mountain and Tod Swank. That really opened my eyes because before that it was all about comic books for me.

http://www.andrewpommier.com

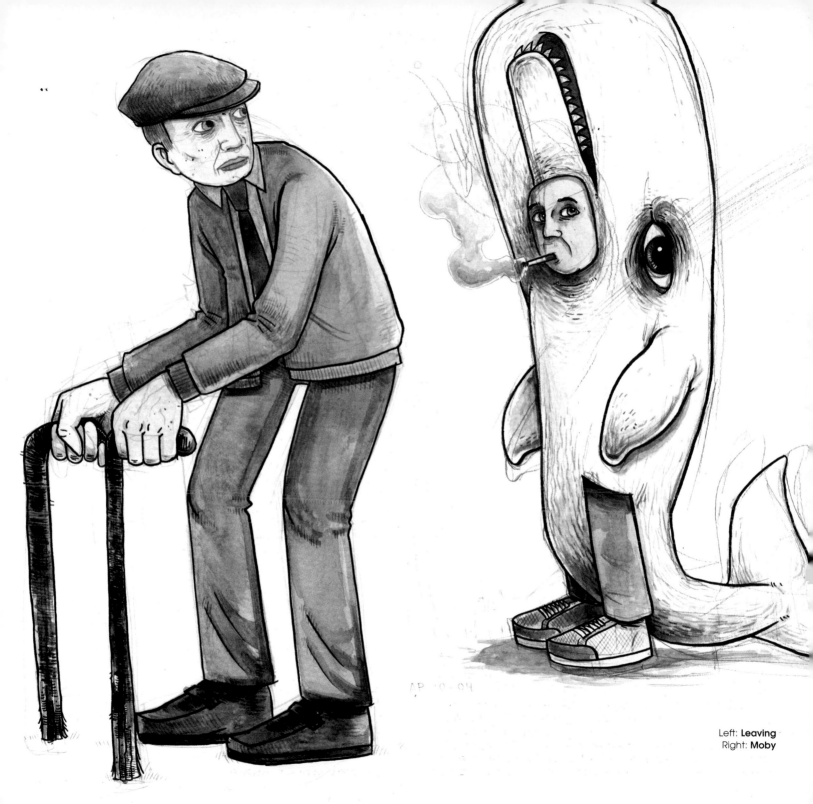

Left: **Leaving**
Right: **Moby**

Andrew Pommier

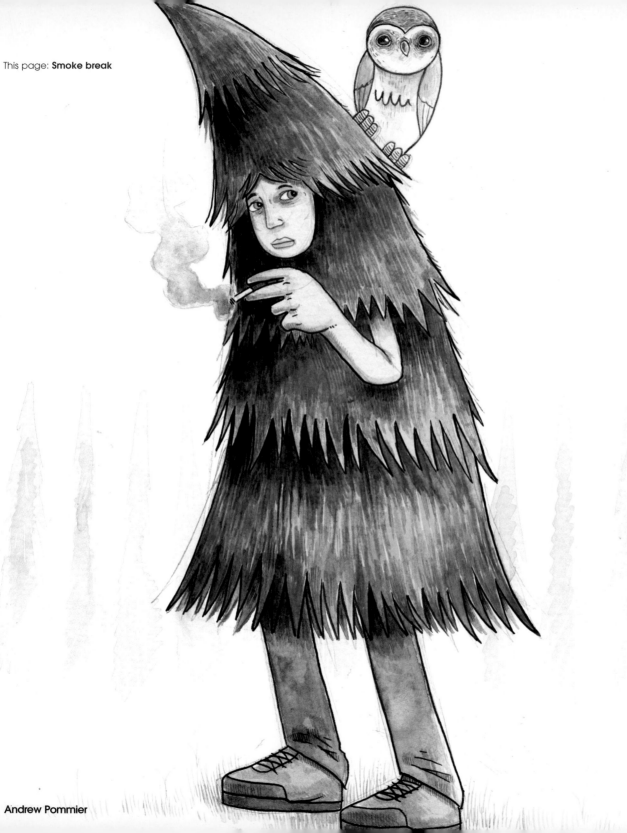

This page: **Smoke break**

Andrew Pommier

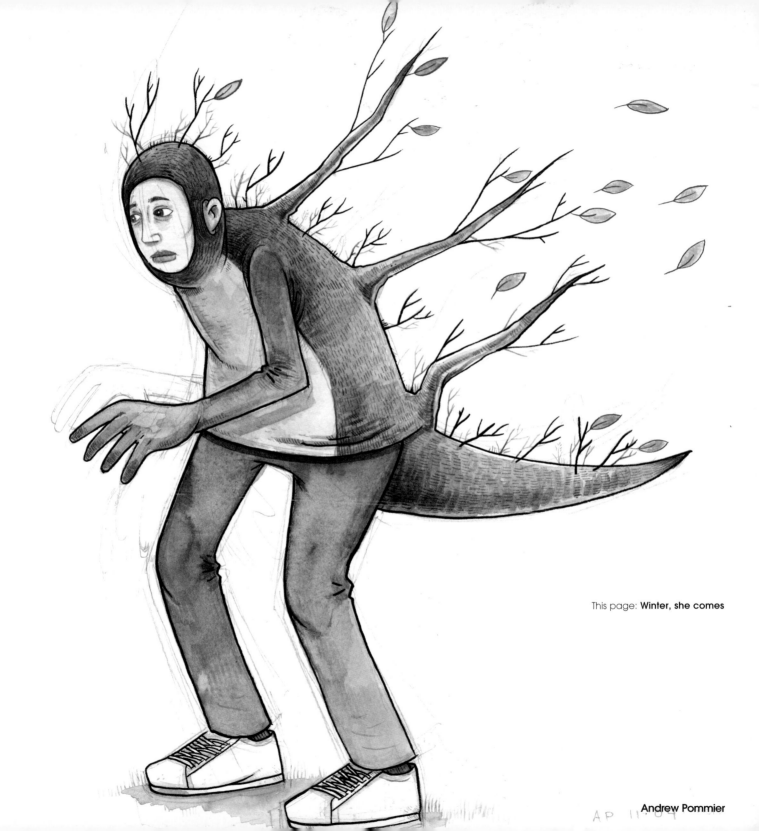

This page: **Winter, she comes**

Andrew Pommier

Bobby Puleo

Bobby Puleo is a professional skateboarder from New York who began collecting objects he found on the street while skating. These collections grew, and he began to group them together in categories that include religious pamphlets, broken CD cases, found cassette tapes, photographs and packaging. The first exhibition of his collections was at the Space 1026 gallery in Philadelphia and achieved critical acclaim, leading to an article in The New York Times. His collections are directly related to both his skateboarding and the environment that he skateboards in – he picks up what is essentially other people's litter as windows into their lives. These collections have been referred to as 'clues about the rest of the world', which was the title of his 2004 exhibition at the New Images Art Gallery in California. He has exhibited throughout America while continuing to add to the collections.

http://www.killerofgiants.com

Above: **Continuation**

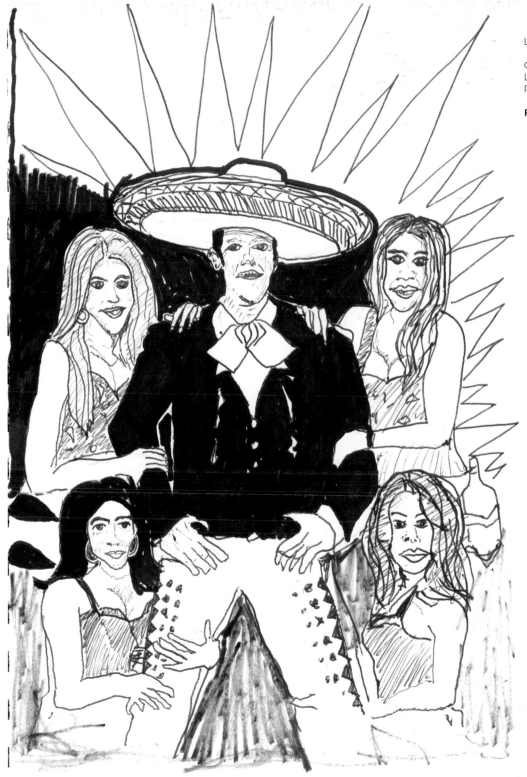

Left: **Harem**

Overleaf:
Left: **Numbers**
Right: **Packaging**

Photos by Angela Boatwright

Bobby Puleo

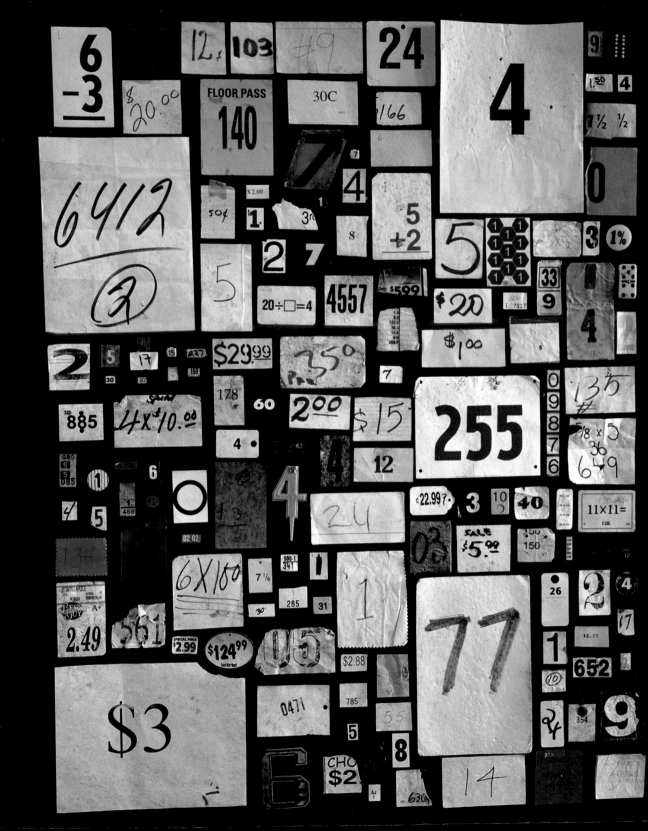

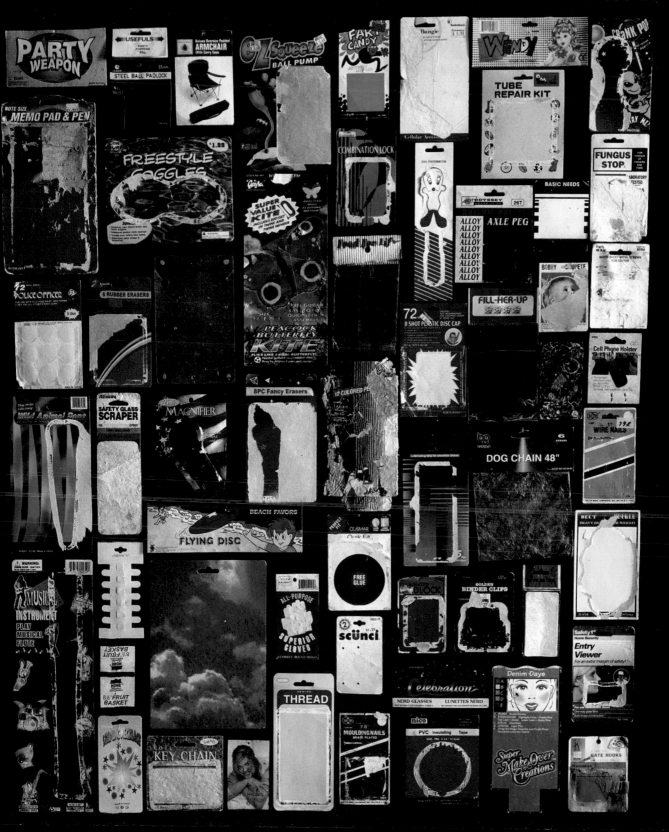

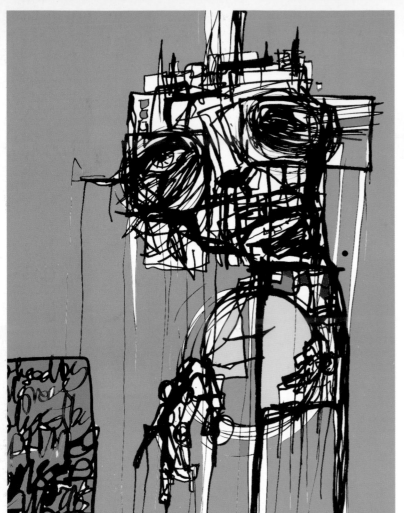
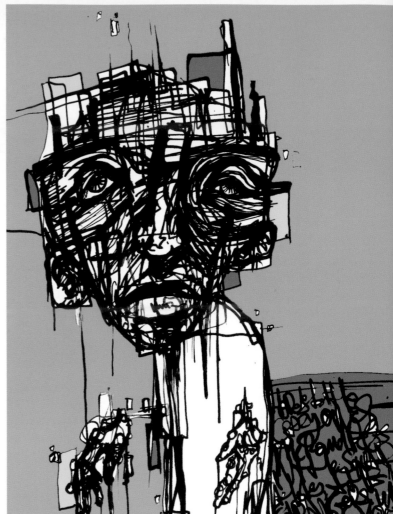

Log Roper

Log Roper is based in Birmingham, UK, and has been skating since 1987: 'Skating and the surrounding culture have always influenced me. I think skate culture nurtures creativity and gives you a good attitude to look at things differently.' He likes to work using lots of different media and formats, including canvas, found wood/objects, different types of paper, old books, aluminium, glass and Perspex. He also likes to use a calligraphy pen and ink to draw: 'I love the quality of ink for scribbling, scratching and mark making, and the accidental drips and bleeds you get on different surfaces.' Initially he was influenced by skateboard graphics, but studying art and design at college and for a few years at university opened up his influences and inspirations beyond skating.

My personal practice is wide and varied but my current focus is on the Outcrowd, which is a collective of skatey creative types and friends, started by me and Si Peplow earlier last year. This was formed to create an outlet for the doodlers, a chance to make work with no necessary agenda.

http://www.outcrowdcollective.com

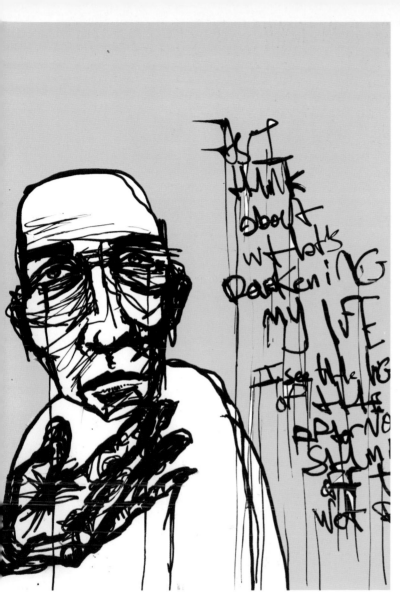
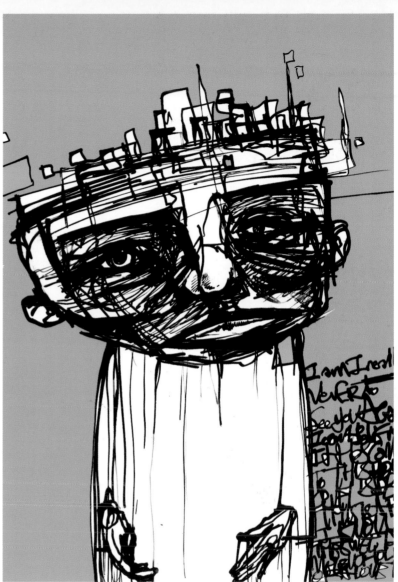

Spread: **Broken heart sketches**

107

Log Roper

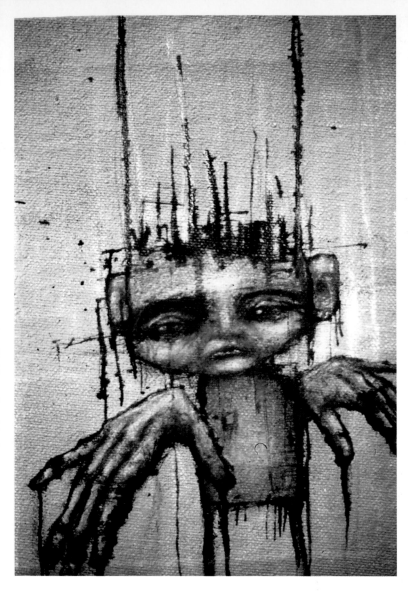

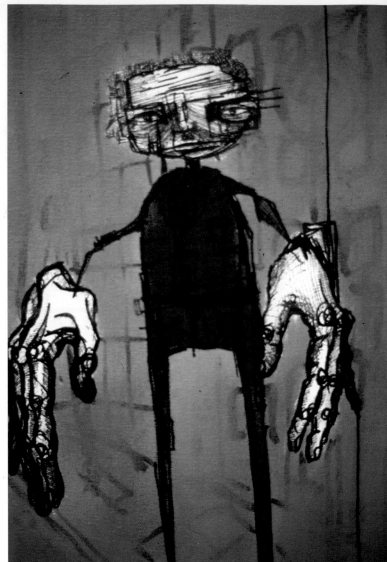

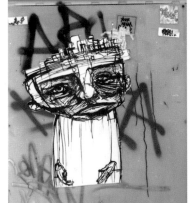

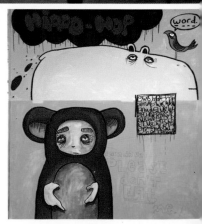

Above left: **Big dogs**
Above right: **Luka**
Right: **Paste up & Hippo hop**

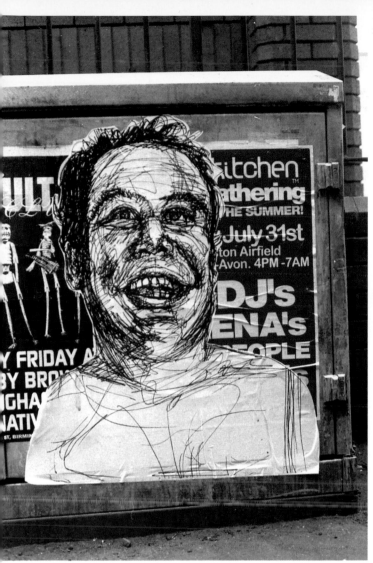

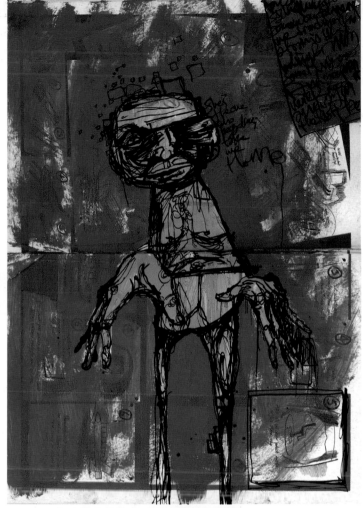

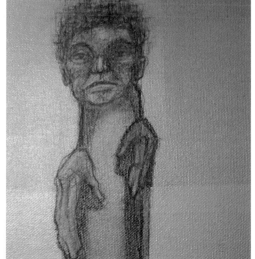

Above: **Paste up**
Above right: **T B Annual**
Right: **Nally**

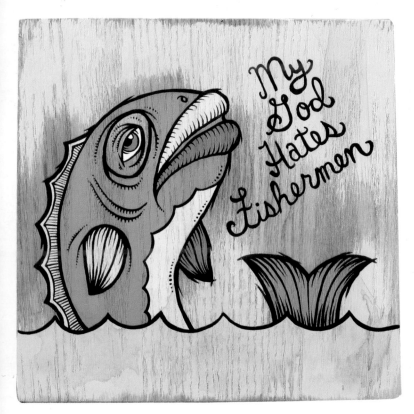

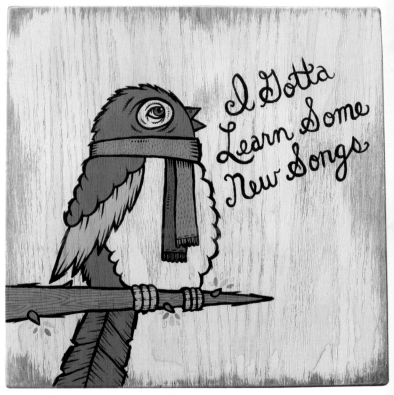

Michael Sieben

Michael Sieben is from Austin, Texas. He divides his time between working as a staff writer and illustrator for Thrasher magazine and as the art director for design company Terrible One. He is also co-owner of the Camp Fig art gallery. He describes his personal work as 'highly illustrative paintings that I hope look like imagery from creepy children's books that were found in a dumpster.' Michael grew up reading Thrasher magazine and was inspired by the thick black line-work he saw outlining certain skateboard graphics.

All of my favourite skateboard artists had a way of laying down that line so that there was no question whose hand it came from. That was what I always strived to do, to come up with a way of working with line that would serve as a personal signature of sorts. It was 18 years ago that I first started skateboarding, and I'm so thankful for everything I've discovered because of it.

http://www.msieben.com

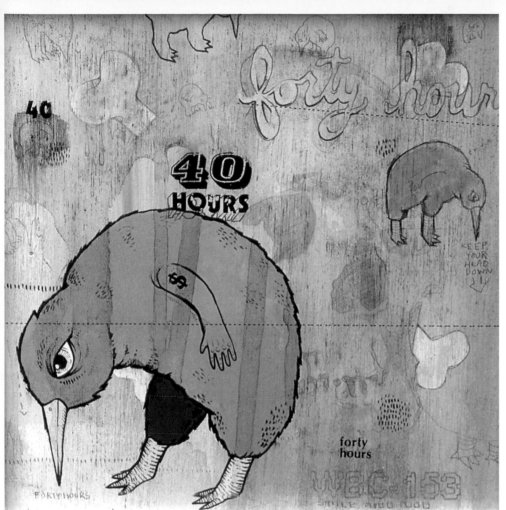

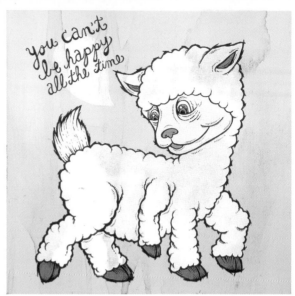

Above: **All the time**
Left: **Forty hours**
Below left: **Because I said so**

Opposite page:
Left: **My god hates fishermen**
Right: **I gotta learn some new songs**

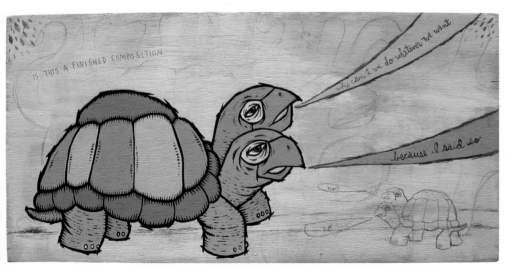

Michael Sieben

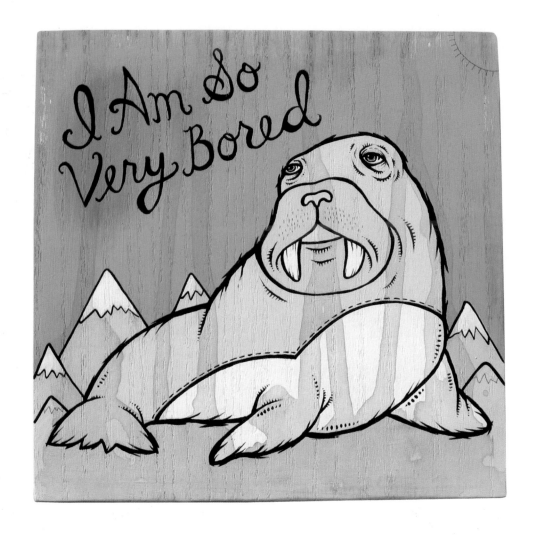

Above: **I am so very bored**

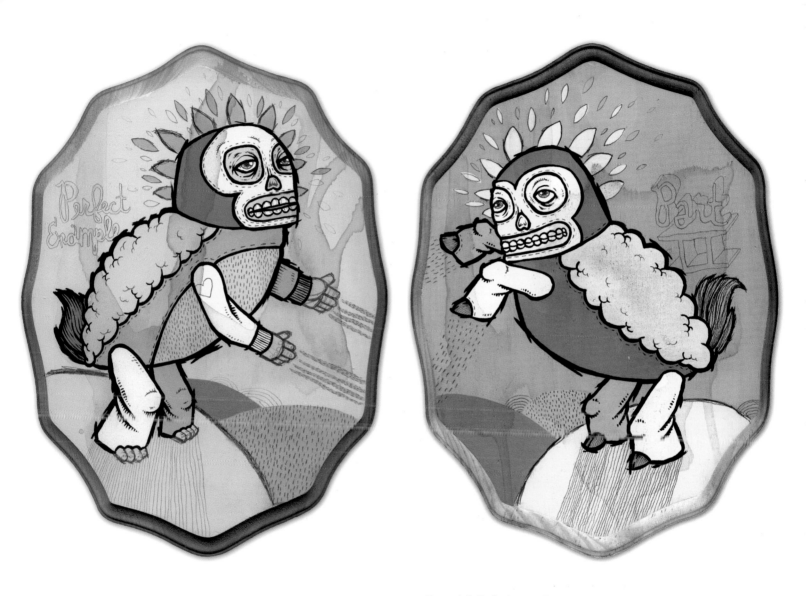

Above left: **Perfect example**
Above right: **Perfect example part II**

Michael Sieben

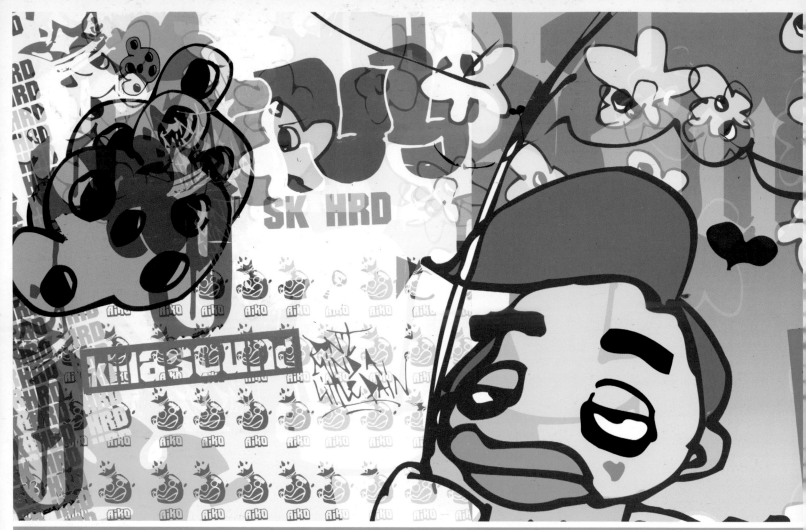

Niko Stumpo

Niko Stumpo was born in Norway but moved to Italy at a young age. He was a professional skateboarder for a number of years before a knee injury meant an early end to his career. This gave him time to concentrate on art and design, which had always been a secondary interest, and something he excelled at. He decided to take the route of web design rather than the more traditional forms of art he had previously been involved with, and it was not long before, at just 24, he was considered Milan's top web/Flash designer. As well as his digital work, he continues to paint and has exhibited throughout Europe. His experimental website, www.abnormalbehaviorchild.com, has cemented his reputation as one of Europe's most talented and creative web designers. He is also involved in producing designs for online T-shirt company Aiko. He currently lives and works in Amsterdam.

http://www.abnormalbehaviorchild.com
http://www.weareaiko.com

Above: **Digital artwork**
Opposite page: **Poster illustration**

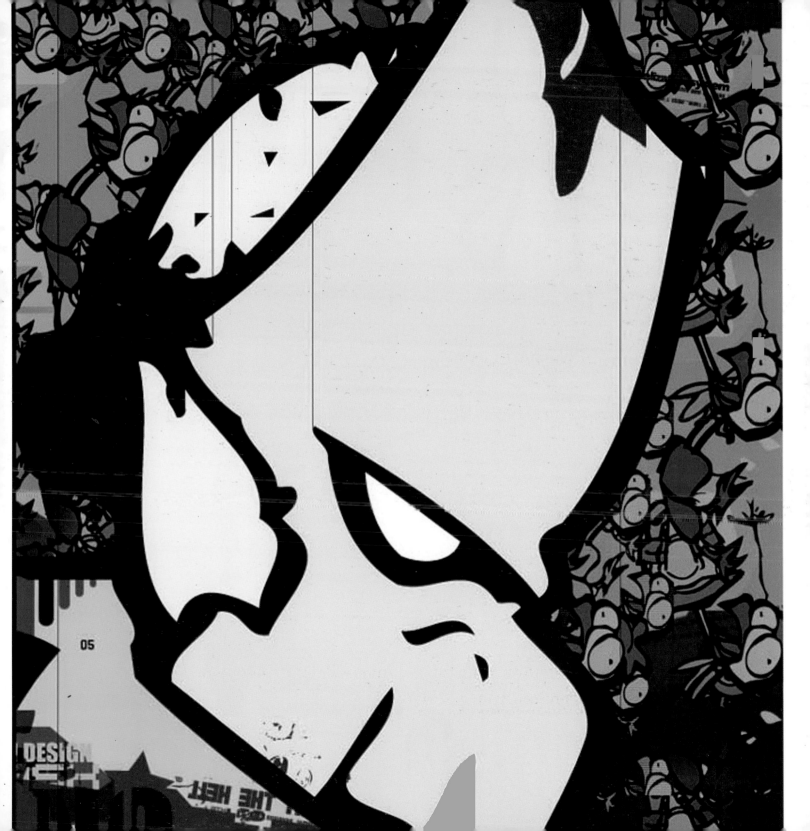

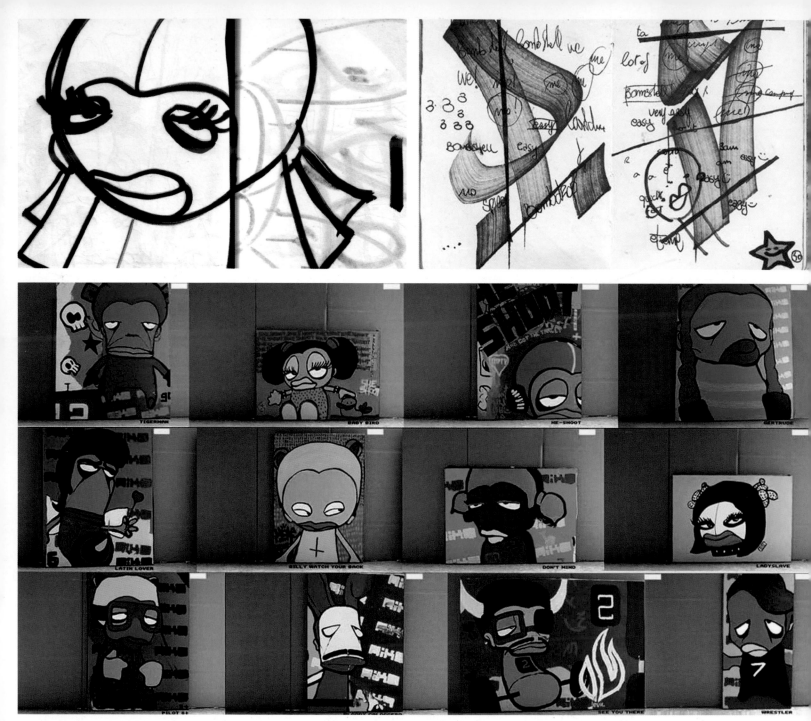

Top left & right: **Sketchbook pages**
Above: **Various character canvases**
Opposite page: **Poster illustration**

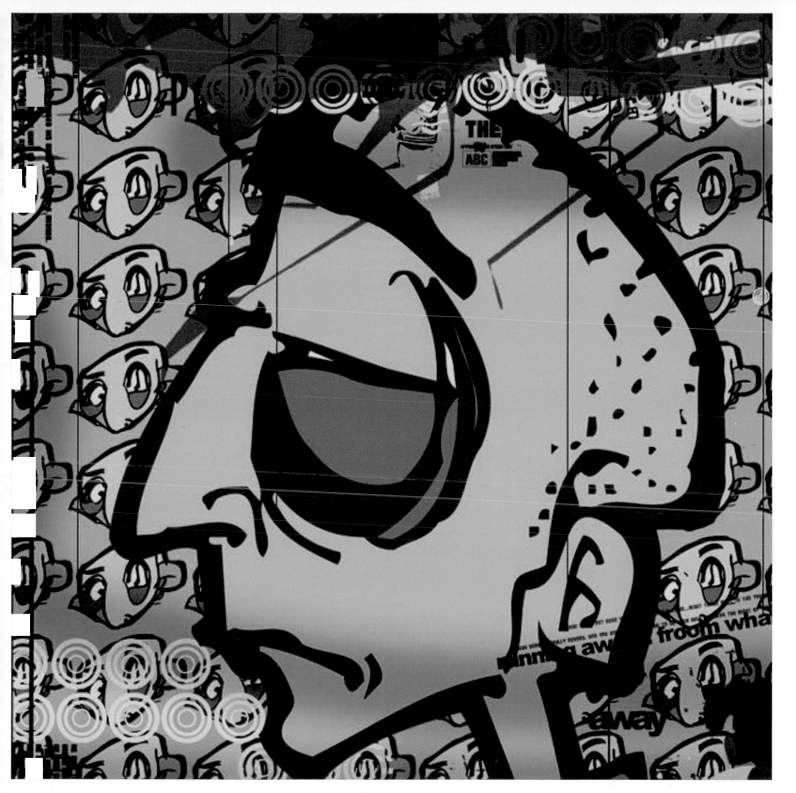

Niko Stumpo

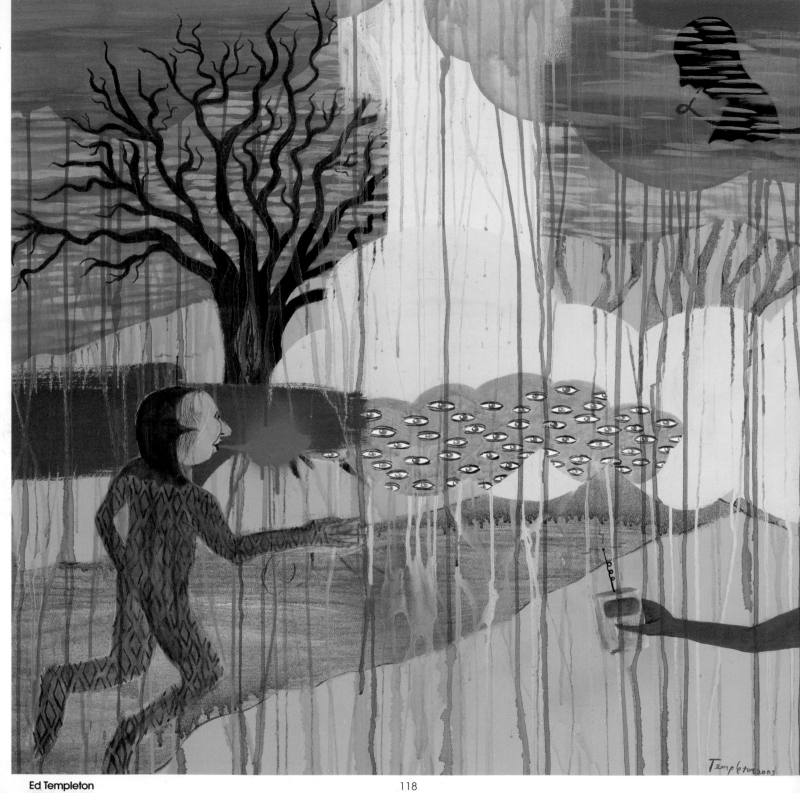

Ed Templeton

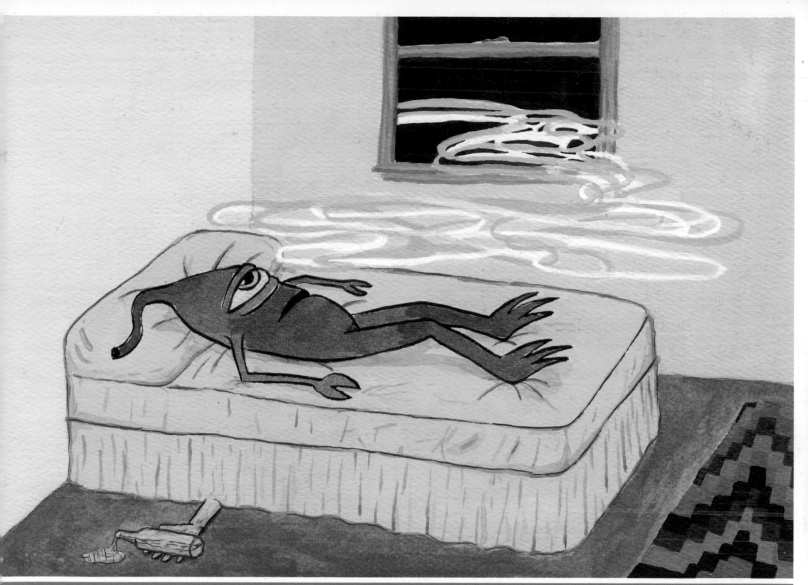

Ed Templeton

Ed Templeton became a pro skateboarder in 1990. In 1993 he started his own company, Toy Machine Bloodsucking Skateboard Company, where he is president, acting team manager and graphic designer, as well as a team rider for the company. It was in 1994 that he took up art, practising painting, drawing, graphic design and photography. Since then he has taken part in solo and group shows throughout the US and Europe. In 2000 he won the top prize at an Italian art show for his series of photographs depicting and entitled 'Teenage Smokers'. He currently lives in Huntington Beach, California, with his wife Deanna, who is often the subject of his work.

http://www.toymachine.com

Above: **Sect on bed colab with AJW**
Left: **Radio controlled**

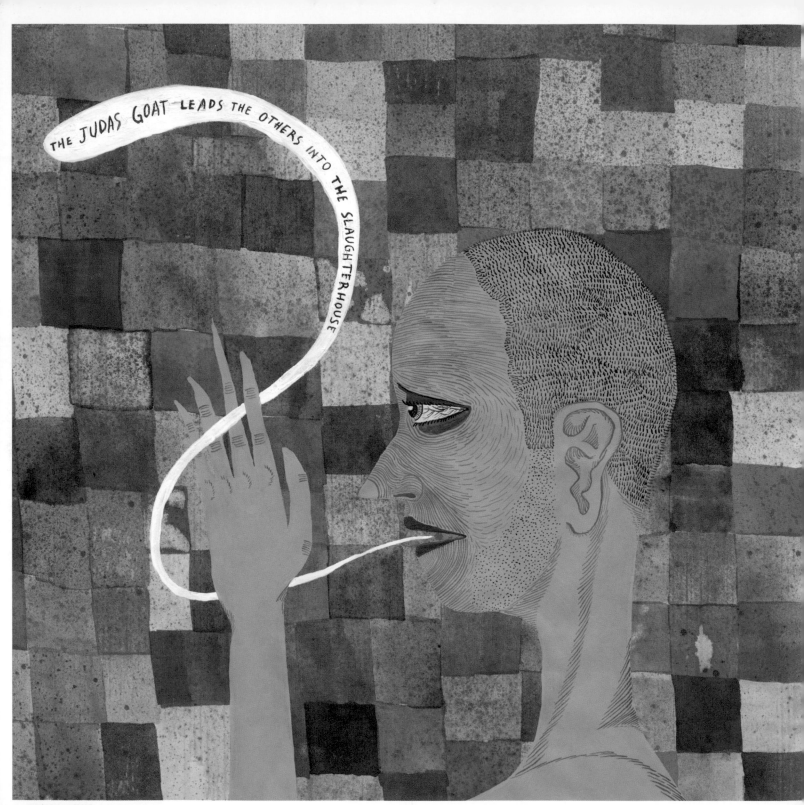

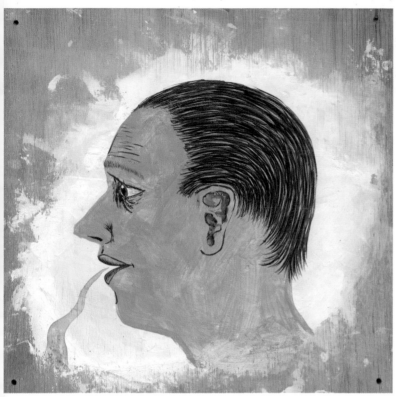

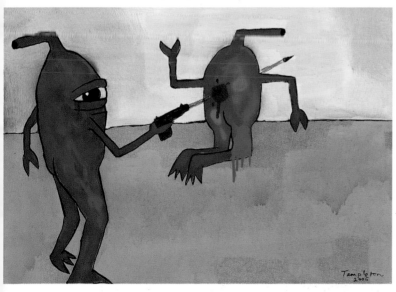

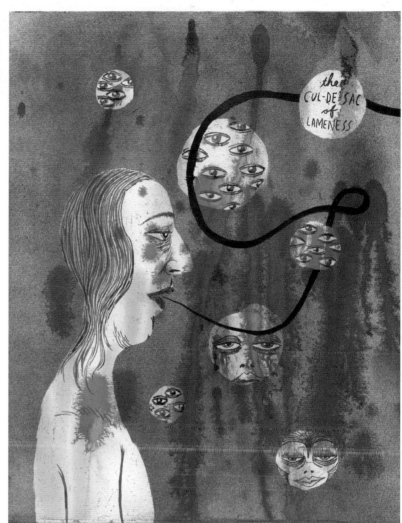

Opposite page: **Judas goat**
Above: **Cul de sac**
Above left: **Profile on wood**
Left: **Sect painting**

Ed Templeton

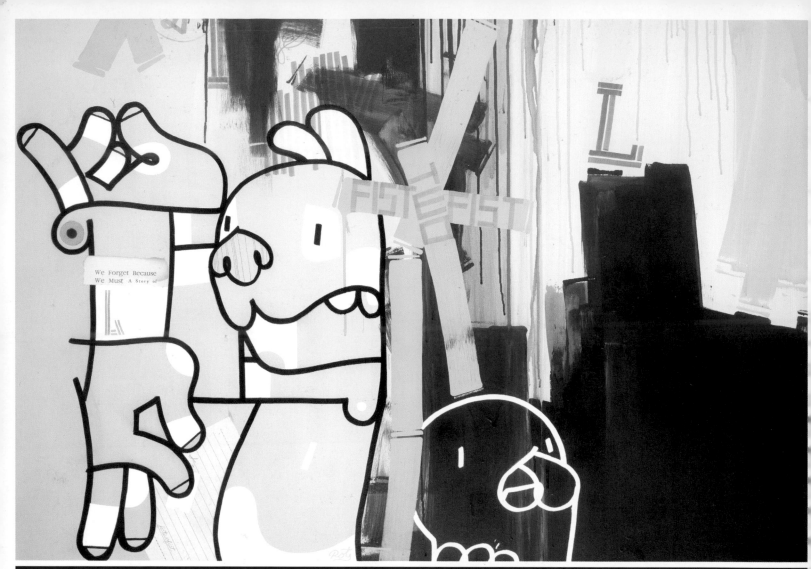

Chris Yormick

Chris Yormick, originally from the District of Columbia, is an artist and former graffiti artist currently living in New York City. His first art-based job within the skate industry was for his friend Chris Hall at Element Skateboards (originally called Underworld Element). Chris has been the art director of skate shoe brand éS, and was also art director at Skateboarder magazine for four years following its re-launch. Chris now concentrates on his art, which is a fusion of graffiti, fine and abstract art in mixed media on canvas.

http://www.chrisyormick.com

Above: **Fist two fist**

Opposite page
Left: **Keep em crossed**
Right: **Sleeping elephant**

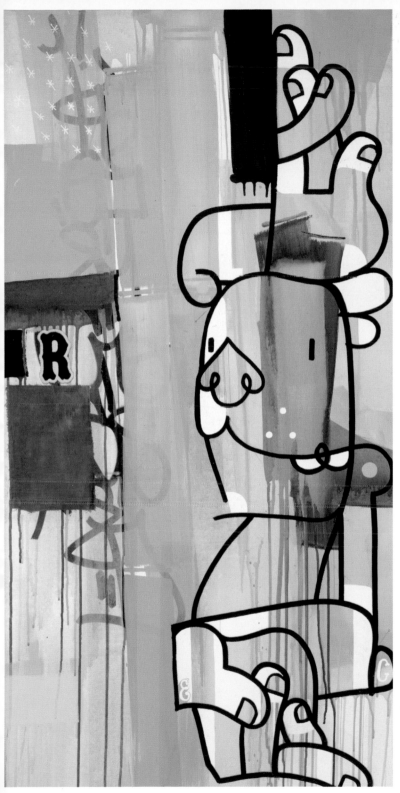
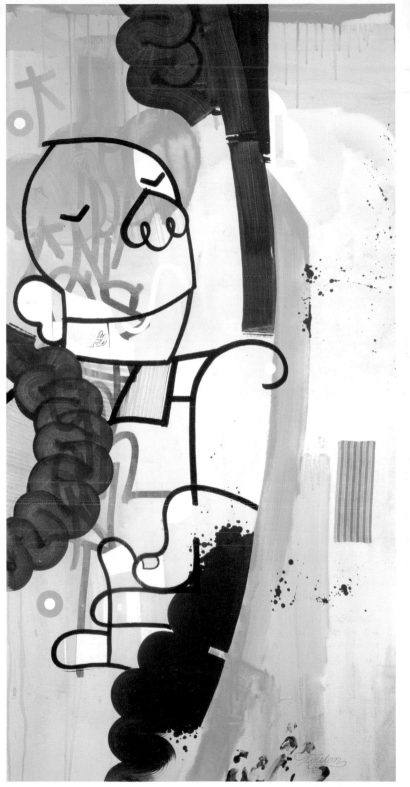

Chris Yormick

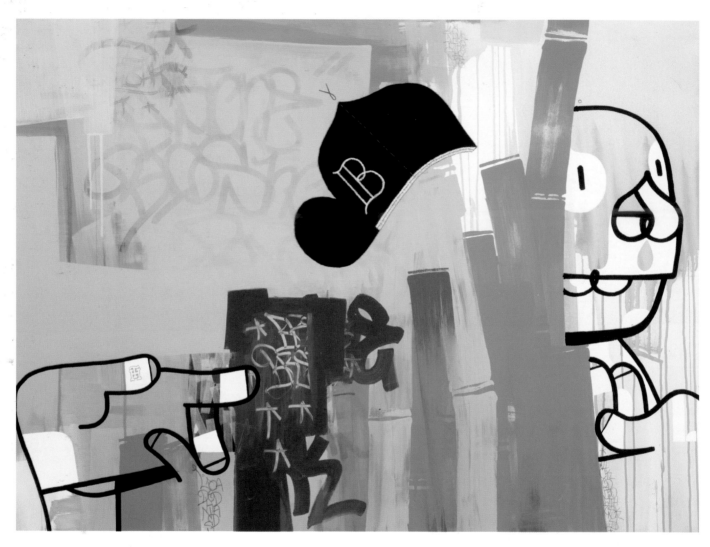

Above: **Loaded hands**

Opposite page
Top: **13ounce**
Below left: **The key**
Below right: **One swift night**

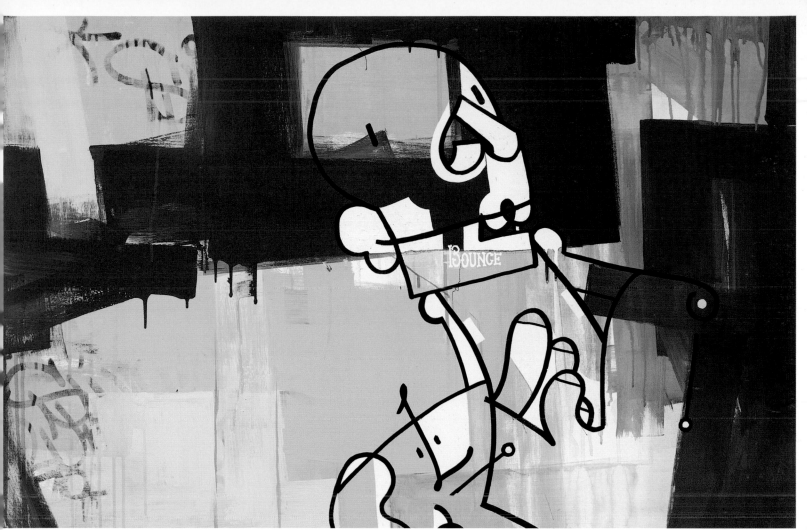

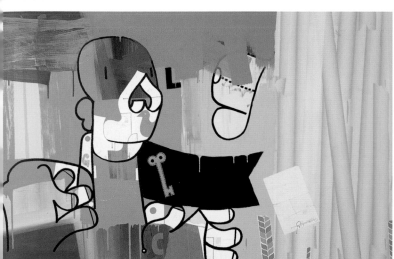

Chris Yormick

About the Authors

Jo Waterhouse is from Birmingham, and is the co-founder, editor and content generator for www.coldspace.net, a unique, fast-growing online resource focusing on skateboarding, art and design.

(jo@coldspace.net)

David Penhallow is a graphic and multimedia designer from Worcester. He is the co-founder and designer of www.coldspace.net and has completed many personal and commercial projects for both web and print.

(dave@coldspace.net)